From *The Doctors' Prescription for Healthy Living*

# Healing
# HEPATITIS
# Naturally

How clinically validated natural medicines can
enhance the healing response and complement
mainstream hepatitis therapeutics

## Healing HEPATITIS Naturally

Copyright, 2000

Disclaimer: The material in this presentation is for informational purposes only and not intended for the treatment or diagnosis of individual disease. Please, visit a qualified medical health professional for specifically diagnosing any ailments mentioned or discussed in detail in this material.

This information is presented by independent medical experts whose sources of information include studies and patient reports from the world's medical and scientific literature.

First Printing, September 2000
Published by Freedom Press
1801 Chart Trail
Topanga, CA 90290
Bulk Orders Available: (310) 455-2995
E-mail: freedompress@aol.com

ISBN: 1-893910-15-6

Cost: $5.95 (U.S.) $8.95 (Canada)

# Table of Contents

# INTRODUCTION

# Naomi Judd
# Blazes Complementary
# Healing Pathway

IN 1987, COUNTRY STAR NAOMI JUDD was frequently feeling ill, suffering chronic fatigue, low-grade temperature, chronic headache and depression, and a sense of weariness that she felt in her bones. By 1989, her doctors told her she had cytomegalovirus. They couldn't have been more wrong.

Even though Naomi is a registered nurse, she couldn't fathom that she would have liver disease. She had never used IV drugs, was monogamous and had never even been drunk in her life. But by 1989, she was unable even to get out of bed.

"After a concert I would literally fall on to my bed on Wynonna's and my bus in my stage outfit and high heels and fall into a deep sleep," she says.

In January 1990, Naomi learned she had hepatitis, an inflammation of the liver caused by viral or bacterial infection or toxic agents. She was told the disease would probably kill her within three years and was forced to retire from her beloved singing career with her daughter Wynonna. Her doctors, however, couldn't readily identify the particular type of hepatitis. It was neither A nor B—that was all they knew.

## PLAY ACTIVE ROLE IN YOUR HEALTH CARE

One of the important lessons from Naomi's experience is to take an active role in your health care. Ask questions. Have tests repeated. Know their accuracy. Naomi, for example, received one of the first hepatitis C tests that had just been approved at that time by the Food and Drug Administration but was told by a prestigious medical institution that her tests were negative.

What her doctors never told her was that the original hepatitis C test she had been given was not particularly sensitive and better tests had been developed. Naomi went five years without a proper diagnosis and, therefore, without proper treatment. Not until 1994—seven years following her first symptoms—did she receive the correct diagnosis of hepatitis C.

"This should be a clear warning to you that you must get involved in your own health," she says today.

## PAIN: PRISM, NOT PRISON

For five years, Naomi received interferon treatment from a well-known medical facility in Nashville. Interferon stimulates the body's immune system to fight viral infections and affects the ability of viruses to divide in liver cells. Patients with chronic hepatitis C, like Naomi, occasionally benefit from interferon. Yet, she recalls that her interferon treatment "produced some of the worst side effects on my medical record."

Naomi survived this particularly trying period of her life by seeking a larger meaning that took her beyond her pain. Rather than allowing her pain to become a prison, it became a prism through which she saw life with a cleansed, renewed sense of vision.

### Hepatitis C Background

Naomi may have contacted the virus from an accidental needle stick while she worked as a registered nurse. Hepatitis C can be transmitted by blood transfusions, bodily fluids or contaminated needles. It is more common than HIV, infecting more than four-million Americans and killing eight- to ten-thousand people annually. The death toll from hepatitis C is expected to triple over the next twenty years.

"It was important to me to step out in faith, pray the answer instead of the problem, live beyond my immediate physical circumstances and strive to be a ray of hope. . . ." she says. "Somehow with God's grace, I've kept going."

"It was lifestyle changes in my personal voyage of self discovery that led me to wholeness and healing," she adds. "My faith, my experience with complementary therapies, my family and my friends, my sense of purpose in helping others . . . have served me well . . ."

## SEEKING 'DR. RIGHT'

Even after the interferon, Naomi's liver biopsies were not particularly promising. She also went through several doctors, trying to find one with whom she connected, which finally happened in November 1995.

Because so little is known about a cure for hepatitis C, the drug of choice is interferon, which was again administered, this time a different brand at a different dosage, by her liver specialist, Bruce R. Bacon, M.D., professor of internal medicine and director of the division of gastroenterology and hepatology, Saint Louis University School of Medicine.

At that time, she was put on the Scherring-Plough Intron (three-million units, three times a week) which she gave herself via injections in her abdomen.

"My side effects were so severe I was once rushed to the emergency room in the middle of the night."

## HEALING MIRACLE

Although interferon may work in only about 10 to 20 percent of hepatitis C cases, by May 1997, when Naomi had completed a year-long regimen of interferon injections, her liver biochemistry values were within the normal range. The pathology report on her latest liver biopsy showed improvement, too. Even better news came at the National Hepatitis Summit in Washington, D.C., when Dr. Bacon announced that Naomi's body currently showed no signs of the hepatitis C virus in repeated blood tests. "If her current condition continues for several years, we would call that a cure."

## SEEKING COMPLEMENTARY PATHWAYS

Also important to Naomi's healing journey was her understanding that she would need to look beyond her doctor's drugs and treatments—while not rejecting these modern miracles which are often so important to overcoming hepatitis. She knew she would need to find the right natural healing pathways that could complement her doctor's treatments and possibly even enhance their outcome. This is called complementary medicine and involves use of clinically validated natural medicines and other therapeutic approaches that will enhance the body's healing response. That is what this book is about—particularly use of natural medicines.

These days, Naomi continues to raise money for liver research, seeking a cure for hepatitis C. And certainly

advances in treatment are being made. That is why we advise hepatitis sufferers to not reject mainstream medicine but rather to combine their doctors' treatments with natural healing pathways that can play a supportive, or, in some cases, perhaps a major healing role.

"I know that there is nothing different or special about me," Naomi tells us. "I believe that I've been given whatever visibility or opportunities I might have today to reach out and encourage you and take you to a higher level. You're smarter than you think you are. You are stronger than you know. Stop and think about the diseases that killed us a hundred years ago, typhoid, polio, pneumonia, common toothaches, diphtheria, tetanus. Now realize because of our commitment, in the near future, today's deadly diseases like hepatitis, AIDS and cancer will also be passé. Only you know what you're doing to be part of our solution. I encourage you to cling to hope.

"I may not know your name or your face, but I know you're out there. I know your pain. I know your fears. I know your sorrow. I'm fighting the same battle you are."

*Behind every pretty face . . .*

**The Doctors' Prescription
for Healthy Living
December 2000**

# ONE
# Hepatitis 101: An Overview

HEPATITIS IS AN ANCIENT DISEASE. The first report of contagious or infectious type of liver disease or jaundice came from Germany in 751 A.D. in a personal communication from a letter by Pope Zacharias to St. Boniface, Archbishop of Mainz.

Rokitansky in 1842 described jaundice due to massive necrosis of liver and named it acute yellow atrophy. Virchow in 1865 suggested that the benign transient form of jaundice usually seen in young persons was due to inflammation which included small, nipplelike projections of water with a mucous plug. He proposed the name "Icterus Catarrhalis."

In 1890 Flindt more accurately suggested that the essential lesion was degeneration of liver tissue and in 1912 Cockayne independently reached the same conclusion. Now that it was well understood that icterus (another word for jaundice which in itself is derived from Old French *jaunisse* or yellow) resulted from an inflammation of the liver, abundant confirmation followed, particularly from the Scandinavians Lindstedt, Ehrstron, Wallgren, Eppinger and later Stilzer in 1876, and, finally, Frolich in 1879 who uncovered the first evidence of liver cell degeneration in early stages

of disease. They conclusively demonstrated that inflammatory jaundice, epidemic hepatitis and some cases of acute yellow atrophy were all manifestations of the same disease.

In both the 18th and 19th centuries infectious hepatitis was a disease of military importance. The French designated it "Jeunisee descamps" and the Germans "Kriegsikoruror Soldatengelbsucht." Yeogt in Germany was the first to demonstrate infectivity of the disease in volunteers. Roholm and Iversen in 1939 developed a technique of liver biopsy and Dible, McMichael, Sherlock in England and Axenfeld and Brass in Germany utilized the knowledge with great success in terms of reducing public spread of the disease. Still, in the United States, there were 72,000 cases in 1961, the highest incidence for any year since the disease had first begun to be reported in 1952.

Today, each year more than 25 million Americans are afflicted with liver and gallbladder diseases and more than 43,000 die of liver disease each year, according to the American Liver Foundation. There are few effective treatments for most life-threatening liver diseases including hepatitis, except for liver transplants. Research has recently opened up exciting new paths for investigation, but much more remains to be done to find cures for more than 100 different liver diseases. What many persons with liver disease, especially hepatitis, need to know, however, is that although natural medicine can help in many cases of liver disease, working with a doctor is essential, just as it is usually essential to utilize their doctors' treatments.

When it comes to hepatitis and related conditions such as cirrhosis, people are filled with mixed emotions. We've all had friends who abused their liver in their youthful days, living a "rock and roll" lifestyle, dangerously indulging in

alcohol and/or street drugs. David Crosby and Mickey Mantle are examples of persons whom many of us have admired and even loved but who indulged in dangerous substance abuse. Fortunately for Crosby, he was the recipient of a life-saving liver transplant.

We've also known people or heard reports in the press about people whose livers were damaged from use of medically prescribed or over-the-counter drugs. Most notable are cases wherein people who have had relatively small amounts of alcohol also used medical drugs such as acetaminophen (e.g., Tylenol), suffering extensive, sometimes deadly liver toxicity (i.e., hepatotoxicity). Alcohol and over-the-counter and prescription medications can be a dangerous, life-threatening combination. However, these are by no means the only drugs that can cause liver damage. Even prescription drugs for lowering cholesterol can damage liver function.

But even if you don't engage in high-risk behaviors or use medical drugs with potential liver-related complications, don't think you are invulnerable to liver disease. Even those persons who have embraced healthy habits can be blindsided because the damage can come from unseen enemies—bacterial and viral pathogens in our food and water, and transmitted via needle sticks or bodily contact. In the United States there are more than four million "carriers" of hepatitis, people who are not ill themselves, but may pass hepatitis on to others.

Take country singer Naomi Judd. Her bout with hepatitis C may have resulted from a needle stick when she was a practicing nurse. The great Chicago Bears running back Walter Payton seemed to have done everything right in his life, only to have been blindsided by liver disease, which in 1999 claimed his life.

And with free trade a modern global reality, no one can be certain any longer that their foods, including fresh produce, are safe from hepatitis-causing pathogens.

In particular, hepatitis (meaning an inflammation of the liver) is caused by several different viruses. Hepatitis A is spread through contaminated water and food and is excreted in the stools. Hepatitis B is acquired from transfusions or other blood products. It can be transmitted through minute cuts or abrasions or by such simple acts as kissing, tooth brushing, ear piercing, tattooing, having dental work or during sexual contact. It can be transmitted from a pregnant woman to her baby. Hepatitis C, formerly called non-A, non-B hepatitis, is primarily spread through infected blood. It causes cirrhosis in 50 percent of cases.

Thus, taking care to insure a strong immune system, reducing high risk behavior, getting regular check-ups, eating a healthy diet, and using a clinically validated daily liver care supplement are all important facets of a total liver health program. These recommendations are all the more important if one has had or currently has active hepatitis.

In hepatitis, the liver often becomes tender and enlarged, and the patient usually exhibits symptoms including fever, weakness, nausea, vomiting, jaundice, and aversion to food which can result in marked weight loss. The virus may be present in the bloodstream, intestines, feces, saliva and in other bodily secretions.

Hepatitis is common in the United States but even more so in developing nations, and some forms of it can be extremely infectious. Most people recover from viral forms of the disease without treatment, but some die and others may develop a chronic, disabling illness.

A vaccine for hepatitis B has been shown to be safe and effective in the prevention of infection if given before exposure. It is recommended for all infants, those persons who come into contact with blood in their work, and for anyone with more than one sex partner. Treatments with interferon are effective in some cases of hepatitis B and C. A vaccine for hepatitis A was recently approved. It is effective in protecting over 90 percent of those who are vaccinated for at least six to twelve months and perhaps much longer.

## THE LIVER: VITAL TO HEALTH

We can live without full use of a finger or even without full vision in both eyes—but we have only one liver, without which we simply cannot live.

This vital organ performs many complex functions. Some of these are:

▲ To convert food into chemicals necessary for life and growth.

▲ To manufacture and export important substances used by the rest of the body.

▲ To process drugs absorbed from the digestive tract into forms that are easier for the body to use.

▲ To detoxify and excrete substances that would be poisonous otherwise.

Your liver plays a key role in converting food into essential chemicals of life. All of the blood that leaves the stomach and intestines must pass through the liver before reaching the rest of the body. The liver is thus strategically placed to process nutrients and drugs absorbed from the digestive tract into forms that are easier for the rest of the body to use. In essence, the liver can be thought of as the body's refinery.

Furthermore, the liver plays a principal role in removing from the blood ingested and internally produced toxic substances. The liver converts them to substances that can be easily eliminated from the body. It also makes bile, a greenish-brown fluid which is essential for digestion. Bile is stored in the gallbladder which, after eating, contracts and discharges bile into the intestine, where it aids digestion.

Many drugs taken to treat diseases are also chemically modified by the liver. These changes govern the drug's activity in the body.

### Your liver helps you by:

- Producing quick energy when it is needed.
- Manufacturing new body proteins.
- Preventing shortages in body fuel by storing certain vitamins, minerals, and sugars.
- Regulating transport of fat stores.
- Regulating blood clotting.
- Aiding in the digestive process by producing bile.
- Controlling the production and excretion of cholesterol.
- Neutralizing and destroying poisonous substances.
- Metabolizing alcohol.
- Monitoring and maintaining the proper level of many chemicals and drugs in the blood.
- Cleansing the blood and discharging waste products into the bile.
- Maintaining hormone balance.
- Serving as the main organ of blood formation before birth.
- Helping the body resist infection by producing immune factors and by removing bacteria from the bloodstream.
- Regenerating its own damaged tissue.
- Storing iron.

## SYMPTOMS AND SIGNS OF LIVER DISEASE

1 ABNORMALLY YELLOW DISCOLORATION OF THE SKIN AND EYES. This is called jaundice which is often the first and sometimes the only sign of liver disease.

2 DARK URINE.

3 GRAY, YELLOW, OR LIGHT-COLORED STOOLS.

4 NAUSEA, VOMITING AND/OR LOSS OF APPETITE.

5 VOMITING OF BLOOD, BLOODY OR BLACK STOOLS. Intestinal bleeding can occur when liver diseases obstruct blood flow through the liver. The bleeding may result in vomiting of blood or bloody stools.

6 ABDOMINAL SWELLING. Liver disease may cause ascites, an accumulation of fluid in the abdominal cavity.

7 PROLONGED GENERALIZED ITCHING.

8 UNUSUAL CHANGE OF WEIGHT. An increase or decrease of more than five percent within two months.

9 ABDOMINAL PAIN.

10 SLEEP DISTURBANCES, MENTAL CONFUSION AND COMA. These conditions, in particular, are present in severe liver disease. These result from an accumulation of toxic substances in the body which impair brain function.

11 FATIGUE OR LOSS OF STAMINA.

12 LOSS OF SEXUAL DRIVE OR PERFORMANCE.

If any of these signs or symptoms appear, consult your physician immediately. Your doctor will perform biochemical liver function tests as well as take a complete history. If you do have liver disease, the earlier it is diagnosed, the greater your chances are for a full recovery.

## HEPATITIS A

Hepatitis A is a liver disease caused by hepatitis A virus (HAV).

### Causes

Hepatitis A virus is spread from person to person by putting something in the mouth that has been contaminated with the stool of a person with hepatitis A. This type of transmission is called "fecal-oral." For this reason, the virus is more easily spread in areas where there are poor sanitary conditions or where good personal hygiene is not observed.

Most infections result from contact with a household member or sex partner who has hepatitis A. Casual contact, as in the usual office, factory, or school setting, does not spread the virus.

### Symptoms

Persons with hepatitis A virus infection may not have any signs or symptoms of the disease. Older persons are more likely to have symptoms than children. If symptoms are present, they usually occur abruptly and may include fever, tiredness, loss of appetite, nausea, abdominal discomfort, dark urine, and jaundice (yellowing of the skin and eyes). Symptoms usually last less than two months; a few persons are ill for as long as six months. The average incubation period for hepatitis A is 28 days (range: 15 to 50 days).

### Diagnosis

A blood test (IgM anti-HAV) is needed to diagnose hepatitis A. Talk to your doctor or someone from your local health department if you suspect that you have been exposed to hepatitis A or any type of viral hepatitis.

**Prevention**

Two products are used to prevent hepatitis A virus infection: immune globulin and hepatitis A vaccine.

Immune globulin is a preparation of antibodies that can be given before exposure for short-term protection against hepatitis A and for persons who have already been exposed to hepatitis A virus. Immune globulin must be given within two weeks after exposure to hepatitis A virus for maximum protection.

Hepatitis A vaccine has been licensed in the United States for use in persons two years of age and older. The vaccine is recommended (before exposure to hepatitis A virus) for persons who are more likely to get hepatitis A virus infection or are more likely to get seriously ill if they do get hepatitis A. The vaccines currently licensed in the United States are HAVRIX® (manufactured by SmithKline Beecham Biologicals) and VAQTA® (manufactured by Merck & Co., Inc).

There is no live virus in hepatitis A vaccines. The virus is inactivated during production of the vaccines, similar to Salk-type inactivated polio vaccine. The hepatitis A vaccine has an excellent safety profile. No serious adverse events have been attributed definitively to hepatitis A vaccine. Soreness at the injection site is the most frequently reported side effect.

Any adverse event suspected to be associated with hepatitis A vaccination should be reported to the Vaccine Adverse Events Reporting System (VAERS). VAERS forms can be obtained by calling 1-800-822-7967.

No instance of transmission of HIV (the virus that causes AIDS) or other viruses has been observed with the use of immune globulin administered by the intramuscular route. Immune globulin can be administered during pregnancy and breast-feeding.

What's more, hepatitis B, diphtheria, poliovirus (oral and inactivated), tetanus, oral typhoid, cholera, Japanese encephalitis, rabies, yellow fever vaccine or immune globulin can be given at the same time that hepatitis A vaccine is given, but at a different injection site.

Although data on long-term protection are limited, estimates based on modeling techniques suggest that protection will last for at least 20 years.

Protection against hepatitis A begins four weeks after the first dose of hepatitis A vaccine. Unfortunately, hepatitis A vaccine is not licensed for use after exposure to hepatitis A virus. In this situation, immune globulin should be used.

Prevaccination screening for likely candidates is done only in specific instances to control cost (e.g., persons who were likely to have had hepatitis A in the past). This includes persons who were born in countries with high levels of hepatitis A virus infection, elderly persons, and persons who have clotting factor disorders and may have received contaminated factor concentrates in the past.

**Persons Who Should Receive Hepatitis A Vaccine**

Hepatitis A vaccination provides protection before one is exposed to hepatitis A virus. Hepatitis A vaccination is recommended for the following groups who are at increased risk for infection and for any person wishing to obtain immunity.

*Persons traveling to or working in countries that have high or intermediate rates of hepatitis A.* All susceptible persons traveling to or working in countries that have high or intermediate rates of hepatitis A should be vaccinated or receive immune globulin before traveling. Persons from

continued on next page

developed countries who travel to developing countries are at high risk for hepatitis A. Such persons include tourists, military personnel, missionaries, and others who work or study abroad in countries that have high or intermediate levels of hepatitis A. The risk for hepatitis A exists even for travelers to urban areas, those who stay in luxury hotels, and those who report that they have good hygiene and that they are careful about what they drink and eat.

*Children in communities that have high rates of hepatitis A and periodic hepatitis A outbreaks.* Children living in communities that have high rates of hepatitis A (e.g., American Indian, Alaska Native) should be routinely vaccinated beginning at two years of age. (High rates of hepatitis A are generally found in these populations, both in urban and rural settings.) In addition, to effectively prevent epidemics of hepatitis A in these communities, vaccination of previously unvaccinated older children is recommended within five years of initiation of routine childhood vaccination programs. Although rates differ among areas, available data indicate that a reasonable cutoff age in many areas is 10 to 15 years of age because older persons have often already had hepatitis A. Vaccination of children before they enter school should receive highest priority, followed by vaccination of older children who have not been vaccinated.

*Men who have sex with men.* Sexually active men (both adolescents and adults) who have sex with men should be vaccinated. Hepatitis A outbreaks among men who have sex with men have been reported frequently. Recent outbreaks have occurred in urban areas in the United States, Canada, and Australia.

*continued on next page*

*Illegal-drug users.* Vaccination is recommended for injecting and noninjecting illegal-drug users if local health authorities have noted current or past outbreaks among such persons. During the past decade, outbreaks have been reported among injecting-drug users in the United States and in Europe.

*Persons who have occupational risk for infection.* Persons who work with hepatitis A virus-infected primates or with hepatitis A virus in a research laboratory setting should be vaccinated. No other groups have been shown to be at increased risk for hepatitis A virus infection because of occupational exposure. Outbreaks of hepatitis A have been reported among persons working with non-human primates that are susceptible to hepatitis A virus infection, including several Old World and New World species. Primates that were infected were those that had been born in the wild, not those that had been born and raised in captivity.

*Persons who have chronic liver disease.* Persons with chronic liver disease who have never had hepatitis A should be vaccinated, as there is a higher rate of fulminant (rapid onset of liver failure, often leading to death) hepatitis A among persons with chronic liver disease. Persons who are either awaiting or have received liver transplants also should be vaccinated.

*Persons who have clotting-factor disorders.* Persons who have never had hepatitis A and who are administered clotting-factor concentrates, especially solvent detergent-treated preparations, should be given hepatitis A vaccine. All persons with hemophilia (Factor VIII, Factor IX) who receive replacement therapy should be vaccinated because there appears to be an increased risk of transmission from clotting-factor concentrates that are not heat inactivated.

## HEPATITIS B

Hepatitis B virus (HBV) can affect anyone. Each year in the United States, more than 200,000 people of all ages get hepatitis B and close to 5,000 die of sickness caused by HBV. If you have had other forms of hepatitis, you can still get hepatitis B.

### Symptoms

You may have hepatitis B (and be spreading the disease) and not know it; sometimes a person with HBV infection has no symptoms at all.

If you have symptoms

▲ your eyes or skin may turn yellow;
▲ you may lose your appetite;
▲ you may have nausea, vomiting, fever, stomach or joint pain;
▲ you may feel extremely tired and not be able to work for weeks or months.

### Causes

One out of 20 people in the United States will get hepatitis B (HBV) some time during their lives.

You get hepatitis B by direct contact with the blood or bodily fluids of an infected person; for example, you can become infected by having sex or sharing needles with an infected person. A baby can get hepatitis B from an infected mother during childbirth. Hepatitis B is not spread through food or water or by casual contact. Sometimes, people who are infected with HBV never recover fully from the infection; they carry the virus and can infect others for the rest of their lives. In the United States, about one million people carry HBV.

Your risk is higher if you:

▲ have sex with someone infected with HBV;

▲ have sex with more than one partner;

▲ are a man and have sex with a man;

▲ live in the same house with someone who has lifelong HBV infection;

▲ have a job that involves contact with human blood;

▲ use illegal injectable drugs;

▲ are a patient or work in a home for the developmentally disabled;

▲ have hemophilia;

▲ travel to areas where hepatitis B is common.

Your risk is also higher if your parents were born in Southeast Asia, Africa, the Amazon Basin in South America, the Pacific Islands, and the Middle East.

If you are at risk for HBV infection, ask your health care provider about hepatitis B vaccine.

### Prevention

There is no cure for hepatitis B; this is why prevention is so important. Hepatitis B vaccine is the best protection against HBV. Three doses are needed for complete protection.

If you have HBV in your blood, you can give hepatitis B to your baby. Babies who get HBV at birth may have the virus for the rest of their lives, can spread the disease, and can get cirrhosis of the liver or liver cancer.

All pregnant women should be tested for HBV early in their pregnancy. If the blood test is positive, the baby should receive the vaccine along with another shot, hepatitis B immune globulin (called H-BIG), at birth. The vaccine series should be completed during the first six months of life.

Persons who should be vaccinated include:

▲ all babies, at birth;

▲ all children 11-12 years of age who have not been vaccinated;

▲ persons of any age whose behavior puts them at high risk for HBV infection;

▲ persons whose jobs expose them to human blood.

## HEPATITIS C

Hepatitis C is a liver disease caused by the hepatitis C virus (HCV), which is found in the blood of persons who have this disease. HCV is spread by contact with the blood of an infected person.

### Causes

HCV is spread primarily by direct contact with human blood. For example, you may have gotten infected with HCV if you:

▲ ever injected street drugs, as the needles and/or other drug "works" used to prepare or inject the drug(s) may have had someone else's blood that contained HCV on them;

▲ received blood, blood products, or solid organs from a donor whose blood contained HCV;

▲ were ever on long-term kidney dialysis as you may have unknowingly shared supplies/equipment that had someone else's blood on them;

▲ were ever a healthcare worker and had frequent contact with blood on the job, especially accidental needle sticks;

▲ were born to a mother who had hepatitis C at the time she gave birth to you (during the birth her blood may have gotten into your body);

▲ ever had sex with a person infected with HCV;

▲ lived with someone who was infected with HCV and shared items such as razors or toothbrushes that might have had his/her blood on them.

Medical and dental procedures done in most settings in the United States do not pose a risk for the spread of HCV. There have, however, been some reports that HCV has been spread between patients in hemodialysis units where supplies or equipment may have been shared between patients.

There is no evidence that HCV has been spread by oral sex.

If HCV is spread within a household, it is most likely due to direct exposure to the blood of an infected household member.

About 5 out of every 100 infants born to HCV infected women become infected. This occurs at the time of birth, and there is no treatment that can prevent this from happening. Most infants infected with HCV at the time of birth have no symptoms and do well during childhood. More studies are needed to find out if these children will have problems from the infection as they grow older. There are no licensed treatments or guidelines for the treatment of infants or children infected with HCV. Children with elevated ALT (alanine aminotransferase, a liver enzyme) levels should be referred for evaluation to a specialist familiar with the management of children with HCV-related disease.

There is no evidence that breast-feeding spreads HCV. HCV-positive mothers should consider abstaining from breast-feeding if their nipples are cracked or bleeding.

Children should not be tested for anti-HCV before 12 months of age as anti-HCV from the mother may last until this age. If testing is desired prior to 12 months of age, polymerase chain reaction (PCR), a qualitative DNA test to detect the absence or presence of the virus, could be performed at or after an infant's first well-child visit at age one to two months.

Persons with HCV should not:

▲ donate blood, body organs, other tissue, or semen;
▲ share personal items that might have their blood on them, such as toothbrushes, dental appliances, nail-grooming equipment or razors.

### Prevention

Don't ever inject street drugs. If you are doing so, stop and get into a treatment program. If you can't stop, never reuse or share syringes, water, or drug works, and get vaccinated against hepatitis A and hepatitis B.

Do not share toothbrushes, razors, or other personal care articles. They might have blood on them.

If you are a healthcare worker, always follow routine barrier precautions and safely handle needles and other sharps. Get vaccinated against hepatitis B.

Consider the health risks if you are thinking about getting a tattoo or body piercing: You can get infected if the tools that are used have someone else's blood on them or if the artist or piercer doesn't follow good health practices, such as washing hands and using disposable gloves.

HCV can be spread by sex, but this does not occur very often. If you are having sex, but not with one steady partner, you and your partners can get other diseases spread by having sex (e.g., AIDS, hepatitis B, gonorrhea or chlamydia). You should use latex condoms correctly and everytime. You should get vaccinated against hepatitis B.

### Diagnosis

There are several blood tests that can be done to determine if you have been infected with HCV. Your doctor may order just one or a combination of these tests. The follow-

ing box shows the types of tests your doctor may order and the purpose for each.

---

**Anti-HCV (antibody to HCV)**

| | |
|---|---|
| ▲ EIA (enzyme immunoassay) | This test is usually done first. If positive, it should be confirmed |
| ▲ RIBA (recombinant immunoblot assay) | A supplemental test used to confirm a positive EIA test |

Anti-HCV does not tell whether the infection is new (acute), chronic (long-term) or is no longer present.

**Qualitative tests to detect presence
or absence of virus (HCV RNA)**

▲ Generic polymerase chain reaction (PCR)
▲ Amplicor HCV™

**Quantitative tests to detect
amount (titer) of virus (HCV RNA)**

▲ Amplicor HCV Monitor™
▲ Quantiplex HCV RNA (bDNA)

---

PCR and other tests to directly detect virus are not licensed tests and are only available on a research-basis. A single positive PCR test indicates infection with HCV. A single negative test does not prove that a person is not infected. The virus may be present in the blood and just not found by PCR. Also, a person infected in the past who has recovered may have a negative test. When hepatitis C is suspected and PCR is negative, PCR should be repeated.

Beware, false positive results. A false positive test means

the test looks as if it is positive, but it is really negative. This happens more often in persons who have a low risk for the disease for which they are being tested. For example, false positive anti-HCV tests happen more often in persons such as blood donors who are at low risk for hepatitis C. Therefore, it is important to confirm a positive anti-HCV test with a supplemental test as most false positive anti-HCV tests are reported as negative on supplemental testing.

There may also be false negative results. Persons with early infection may not as yet have developed antibody levels high enough that the test can measure. In addition, some persons may lack the (immune) response necessary for the test to work well. In these persons, research-based tests such as PCR may be considered.

Anti-HCV can be found in 7 out of 10 persons when symptoms begin and in about 9 out of 10 persons within three months after symptoms begin. However, it is important to note that many persons who have hepatitis C have no symptoms. It is possible to find HCV within one to two weeks after being infected with the virus.

Those who should be tested for hepatitis C include:

▲ persons who ever injected illegal drugs, including those who injected once or a few times many years ago;

▲ persons who were treated for clotting problems with a blood product made before 1987 when more advanced methods for manufacturing the products were developed;

▲ persons who were notified that they received blood from a donor who later tested positive for hepatitis C;

▲ persons who received a blood transfusion or solid organ transplant before July 1992 when better testing of blood donors became available;

▲ long-term hemodialysis patients;

▲ persons who have signs or symptoms of liver disease (e.g., abnormal liver enzyme tests);

▲ healthcare workers after exposures (e.g., needle sticks or splashes to the eye ) to HCV-positive blood on the job;

▲ children born to HCV-positive women.

If hepatitis C is diagnosed, your doctor will measure the level of ALT in the blood. An elevated ALT indicates inflammation of the liver and you should be checked further for chronic (long-term) liver disease and possible treatment. The evaluation should be done by a healthcare professional familiar with chronic hepatitis C.

It is common for persons with chronic hepatitis C to have a liver enzyme level that goes up and down, with periodic returns to normal or near normal. Some persons have a liver enzyme level that is normal for over a year but they still have chronic liver disease. If the liver enzyme level is normal, persons should have their enzyme level re-checked several times over a six to twelve month period. If the liver enzyme level remains normal, your doctor may check it less frequently, such as once a year.

## Complications

Of every 100 persons infected with HCV about:

▲ Eighty-five persons may develop long-term infection.

▲ Seventy persons may develop chronic liver disease.

▲ Fifteen persons may develop cirrhosis over a period of 20 to 30 years.

▲ Five may die from the consequences of long term infection (liver cancer or cirrhosis).

▲ A small percentage of persons with chronic hepatitis C develop medical conditions outside the liver (this is

called extrahepatic). These conditions are thought to occur due to the body's natural immune system fighting against itself. Such conditions include: glomerulonephritis (kidney disease), essential mixed cryoglobulinemia (abnormal forms of protein in the blood), and porphyria cutanea tarda (characterized by photosensitivity and shallow skin ulcers).

### Management and Treatment

A referral to or consultation with a specialist for further evaluation and possible treatment may be considered if a person is anti-HCV positive and has elevated liver enzyme levels. Any physician who manages a person with hepatitis C should be knowledgeable and current on all aspects of the care of a person with hepatitis C.

Antiviral drugs such as interferon used alone or in combination with ribavirin, are approved for the treatment of persons with chronic hepatitis C. Interferon works in 10 to 20 persons out of 100 treated. Interferon combined with ribavirin works (on the viral strain that is mostly found in the U.S.) in about 30 to 40 persons out of 100. Ribavirin, when used alone, does not work.

Most persons have flu-like symptoms (fever, chills, headache, muscle and joint aches, fast heart rate) early in treatment, but these lessen with continued treatment. Later side effects may include tiredness, hair loss, low blood count, trouble with thinking, moodiness, and depression. Severe side effects are rare (seen in less than two out of 100 persons). These include thyroid disease, depression with suicidal thoughts, seizures, acute heart or kidney failure, eye and lung problems, hearing loss, and blood infection.

Although rare, deaths have occurred due to liver failure or

blood infection, mostly in persons with cirrhosis. An important side effect of interferon is worsening of liver disease with treatment, which can be severe and even fatal. Interferon dosage must be reduced in up to 40 out of 100 persons because of severity of side effects, and treatment must be stopped in up to 15 out of 100 persons. Pregnant women should not be treated with interferon.

In addition to the side effects due to interferon described above, ribavirin can cause serious anemia (low red blood cell count) and can be a serious problem for persons with conditions that cause anemia, such as kidney failure. In these persons, combination therapy should be avoided or attempts should be made to correct the anemia. Anemia caused by ribavirin can be life-threatening for persons with certain types of heart or blood vessel disease. Ribavirin causes birth defects and pregnancy should be avoided during treatment. Patients and their healthcare providers should carefully review the product manufacturer information prior to treatment.

You should report what you are feeling to your doctor. Some side effects may be reduced by giving interferon at night or lowering the dosage of the drug. In addition, flu-like symptoms can be reduced by taking acetaminophen before treatment.

Antiviral drugs are not licensed for persons under 18 years of age. Children with hepatitis C should be referred to a children's specialist in liver diseases. You may want to ask your doctor about clinical trials that may be ongoing for children.

### Know Your Genotype

There are six known genotypes and more than 50 subtypes of HCV, and genotype information is helpful in defining the epidemiology of hepatitis C. Knowing the genotype or serotype (genotype-specific antibodies) of HCV is helpful in making rec-

ommendations and counseling regarding therapy. Patients with genotypes 2 and 3 are almost three times more likely than patients with genotype 1 to respond to therapy with alpha interferon or the combination of alpha interferon and ribavirin.

Furthermore, when using combination therapy, the recommended duration of treatment depends on the genotype. For patients with genotypes 2 and 3, a 24-week course of combination treatment is adequate, whereas for patients with genotype 1, a 48-week course is recommended. For these reasons, testing for HCV genotype is often clinically helpful. Once the genotype is identified, it need not be tested again; genotypes do not change during the course of infection.

Persons infected with HCV mount an antibody response to parts of the virus, but changes in the virus during infection result in changes that are not recognized by preexisting antibodies. This appears to be how the virus establishes and maintains long-lasting infection.

Because of the ineffective immune response described above, prior infection does not protect against reinfection with the same or different genotypes of the virus. For the same reason, there is no effective pre- or postexposure prophylaxis (i.e, immune globulin) available.

### Cirrhosis

Cirrhosis of the liver is a degenerative disease where liver cells are damaged and replaced by scar formation. As scar tissue progressively accumulates, blood flow through the liver is diminished, causing even more liver cells to die. The liver becomes less able to carry out its many functions. Loss of liver function results in gastrointestinal disturbances, emaciation, enlargement of the liver and spleen, jaundice, accumulation of fluid in the abdomen and other tissues of

the body. Obstruction of the venous circulation often caus-
es massive vomiting of blood.

Each year over 25,000 Americans die from cirrhosis, the
seventh leading cause of death in the United States. In fact,
between the ages of 25 and 44, cirrhosis is the fourth most
prevalent disease-related cause of death.

*Causes*

Anything which results in severe liver injury can cause cir-
rhosis. Among the most common causes of cirrhosis in the
United States are alcohol addiction, malnutrition, hepatitis,
parasites, toxic chemical exposures, drug reactions, and
congestive heart failure.

Although cirrhosis has many causes, in the United States,
chronic alcoholism and hepatitis C are the most common
causes. Over half of the deaths from cirrhosis of the liver
are caused by alcohol abuse, hepatitis and other viruses.
Some chemicals, many poisons, too much iron or copper,
severe reaction to drugs, and obstruction of the bile duct
can also cause cirrhosis.

Among the causes of cirrhosis:

**ALCOHOLIC LIVER DISEASE.** To many people, cirrhosis of the
liver is synonymous with chronic alcoholism, but in fact,
alcoholism is only one of the causes. Alcoholic cirrhosis
usually develops after more than a decade of heavy drink-
ing. The amount of alcohol that can injure the liver varies
greatly from person to person. In women, as few as two to
three drinks per day have been linked with cirrhosis and in
men, as few as three to four drinks per day. Alcohol seems
to injure the liver by blocking the normal metabolism of
protein, fats, and carbohydrates.

**CHRONIC HEPATITIS C.** The hepatitis C virus ranks with alcohol as the major cause of chronic liver disease and cirrhosis in the United States. Infection with this virus causes inflammation of and low-grade damage to the liver that over several decades can lead to cirrhosis.

**CHRONIC HEPATITIS B AND D.** The hepatitis B virus is probably the most common cause of cirrhosis worldwide, but in the United States and Western world it is less common. Hepatitis B, like hepatitis C, causes liver inflammation and injury that over several decades can lead to cirrhosis. The hepatitis D virus is another virus that infects the liver, but only in people who already have hepatitis B.

**AUTOIMMUNE HEPATITIS.** This type of hepatitis is caused by a problem with the immune system.

**INHERITED DISEASES.** Alpha-1 antitrypsin deficiency, hemochromatosis, Wilson's disease, galactosemia, and glycogen storage diseases are among the inherited diseases that interfere with the way the liver produces, processes, and stores enzymes, proteins, metals, and other substances the body needs to function properly.

**NONALCOHOLIC STEATOHEPATITIS (NASH).** In NASH, fat builds up in the liver and eventually causes scar tissue. This type of hepatitis appears to be associated with diabetes, protein malnutrition, obesity, coronary artery disease, and corticosteroid treatment.

**BLOCKED BILE DUCTS.** When the ducts that carry bile out of the liver are blocked, bile backs up and damages liver tis-

sue. In babies, blocked bile ducts are most commonly caused by biliary atresia, a disease in which the bile ducts are absent or injured. In adults, the most common cause is primary biliary cirrhosis, a disease in which the ducts become inflamed, blocked, and scarred. Secondary biliary cirrhosis can happen after gallbladder surgery, if the ducts are inadvertently tied off or injured.

**DRUGS, TOXINS, AND INFECTIONS.** Severe reactions to prescription drugs, prolonged exposure to environmental toxins, the parasitic infection schistosomiasis, and repeated bouts of heart failure with liver congestion can each lead to cirrhosis.

### Symptoms

According to *The American Medical Association Family Medical Guide*, "In the very early stages, while there are still plenty of healthy liver cells, symptoms are absent or mild. As the disease progresses, however, loss of appetite, weight loss, nausea, vomiting, general loss of sense of well-being, weakness, indigestion and abdominal distention all become increasingly pronounced. There is a tendency to bleed and bruise easily. Small, red, spidery marks called spider nevi may appear on the face, arms, and upper part of the trunk."[1]

In the later states, jaundice may occur. Men may lose interest in sex, their breasts enlarge and they become impotent. Women usually stop having periods. Eventually, liver failure may develop. Fluid retention in the abdomen and ankles, irritability, and an inability to concentrate are the most common symptoms. Memory is impaired and the hands tremble noticeably. Confusion and drowsiness occur

and increase, leading to coma as the condition worsens. Life-threatening bleeding from enlarged veins in the esophagus may also occur.

Many people with cirrhosis have no symptoms in the early stages of the disease. However, as scar tissue replaces healthy cells, liver function starts to fail and a person may experience the following symptoms:

▲ Exhaustion.

▲ Fatigue.

▲ Loss of appetite.

▲ Nausea.

▲ Weakness.

▲ Weight loss.

As the disease progresses, complications may develop. In some people, these may be the first signs of the disease.

### Complications

Loss of liver function affects the body in many ways. Following are common problems, or complications, caused by cirrhosis.

**EDEMA AND ASCITES.** When the liver loses its ability to make the protein albumin, water accumulates in the leg (edema) and abdomen (ascites).

**BRUISING AND BLEEDING.** When the liver slows or stops production of the proteins needed for blood clotting, a person will bruise or bleed easily.

**JAUNDICE.** Jaundice is a yellowing of the skin and eyes that occurs when the diseased liver does not absorb enough bilirubin.

**ITCHING.** Bile products deposited in the skin may cause intense itching.

**GALLSTONES.** If cirrhosis prevents bile from reaching the gallbladder, a person may develop gallstones.

**TOXINS IN THE BLOOD OR BRAIN.** A damaged liver cannot remove toxins from the blood, causing them to accumulate in the blood and eventually the brain. There, toxins can dull mental functioning and cause personality changes, coma, and even death. Signs of the buildup of toxins in the brain include neglect of personal appearance, unresponsiveness, forgetfulness, trouble concentrating, or changes in sleep habits.

**SENSITIVITY TO MEDICATION.** Cirrhosis slows the liver's ability to filter medications from the blood. Because the liver does not remove drugs from the blood at the usual rate, they act longer than expected and build up in the body. This causes a person to be more sensitive to medications and their side effects.

**PORTAL HYPERTENSION.** Normally, blood from the intestines and spleen is carried to the liver through the portal vein. But cirrhosis slows the normal flow of blood through the portal vein, which increases the pressure inside it. This condition is called portal hypertension.

**VARICES.** When blood flow through the portal vein slows, blood from the intestines and spleen backs up into blood vessels in the stomach and esophagus. These blood vessels may become enlarged because they are not meant to carry this much blood. The enlarged blood vessels, called varices,

have thin walls and carry high pressure, and thus are more likely to burst. If they do burst, the result is a serious bleeding problem in the upper stomach or esophagus that requires immediate medical attention.

**PROBLEMS IN OTHER ORGANS.** Cirrhosis can cause immune system dysfunction, leading to infection. Ascites (fluid) in the abdomen may become infected with bacteria normally present in the intestines, and cirrhosis can also lead to kidney dysfunction and failure.

### Diagnosis

The doctor may diagnose cirrhosis on the basis of symptoms, laboratory tests, the patient's medical history, and a physical examination. For example, during a physical examination, the doctor may notice that the liver feels harder or larger than usual and order blood tests that can show whether liver disease is present.

If looking at the liver is necessary to check for signs of disease, the doctor might order a computerized axial tomography (CAT) scan, ultrasound, or a scan of the liver using a radioisotope (a harmless radioactive substance that highlights the liver). Or the doctor might look at the liver using a laparoscope, an instrument inserted through the abdomen that relays pictures back to a computer screen.

A liver biopsy will confirm the diagnosis. For a biopsy, the doctor uses a needle to take a small sample of tissue from the liver, then examines it for scarring or other signs of disease.

### Treatment

Some types of cirrhosis can be treated, but often there is no cure. At this point, treatment is mostly supportive and

may include a strict diet, diuretics, vitamins, and abstinence from alcohol. However, there has been much progress in managing the major complications of cirrhosis such as fluid retention in the abdomen, bleeding, and changes in mental function.

Liver damage from cirrhosis cannot be reversed, but treatment can stop or delay further progression and reduce complications. Treatment depends on the cause of cirrhosis and any complications a person is experiencing. For example, cirrhosis caused by alcohol abuse is treated by abstaining from alcohol. Treatment for hepatitis-related cirrhosis involves medications used to treat the different types of hepatitis, such as interferon for viral hepatitis and corticosteroids for autoimmune hepatitis. Cirrhosis caused by Wilson's disease, in which copper builds up in organs, is treated with medications to remove the copper. These are just a few examples—treatment for cirrhosis resulting from other diseases will depend on the underlying cause. In all cases, regardless of the cause, following a healthy diet and avoiding alcohol are essential because the body needs all the nutrients it can get, and alcohol will only lead to more liver damage.

Treatment will also include remedies for complications. For example, for ascites and edema, the doctor may recommend a low-sodium diet or the use of diuretics, which are drugs that remove fluid from the body. Antibiotics will be prescribed for infections, and various medications can help with itching. Protein causes toxins to form in the digestive tract, so eating less protein will help decrease the buildup of toxins in the blood and brain. The doctor may also prescribe laxatives to help absorb the toxins and remove them from the intestines.

For portal hypertension, the doctor may prescribe blood pressure medication such as a beta-blocker. If varices bleed, the doctor may either inject them with a clotting agent or perform a rubber-band ligation, which uses a special device to compress the varices and stop the bleeding.

When complications cannot be controlled or when the liver becomes so damaged from scarring that it completely stops functioning, a liver transplant is necessary. In liver transplantation surgery, a diseased liver is removed and replaced with a healthy one from an organ donor. About 80 to 90 percent of people survive liver transplantation. Survival rates have improved over the past several years because of drugs such as cyclosporine and tacrolimus, which suppress the immune system and keep it from attacking and damaging the new liver.

## LIVER DISORDERS IN CHILDREN

Tens of thousands of American children—from newborn infants to adolescents—get liver diseases, and hundreds die from them every year. There are more than 100 different types of liver diseases that have been identified in infants

### Liver Disease Prevention

▲ Don't drink more than two alcoholic drinks a day.

▲ Be cautious about mixing several drugs; in particular, alcohol and many "over-the-counter" and prescription medicines do not mix well.

▲ Avoid taking medicines unnecessarily. Also avoid exposure to industrial chemicals whenever possible.

▲ Maintain a healthful, balanced diet.

▲ Consult your physician if you observe any signs or symptoms of liver disease.

and children. The more common of these diseases is chronic active hepatitis, which gradually destroys and replaces the normal liver cells with scar tissue through an unknown auto-immune process which resembles an allergic reaction to the child's own liver tissue.

## COMPLEMENTARY THERAPEUTICS FOR LIVER DISEASE

Our interest in complementary therapies for enhancing the healing response in cases of liver disease has been stimulated by the numerous letters we have received at *The Doctors' Prescription for Healthy Living*, a national consumer health publication, from persons with chronic and malignant liver diseases. Liver disease may not be as sexy or politicized a condition as some diseases like AIDS and cancer that receive enormous amounts of media coverage and public funding, but the statistics and letters tell us that a lot of people are suffering from liver disease—that there are a lot of people in pain, searching, desperately seeking true hope from complementary medicine.

In many cases, the liver can regenerate tissue, so there is often hope for persons with liver disease for a partial or full recovery, especially if caught early. What's more, complementary medicine that embraces both natural healing medicines and doctors' high-powered drugs can help persons with liver disease in a synergistic manner. Our message is clear: complementary therapy is probably superior to an approach that relies on one or the other without combining them.

For these reasons, it is imperative that we introduce persons with liver disease to clinically validated natural medicines that can initiate and enhance the healing process, protect the liver tissues and prevent further damage.

In the next section, we will detail how to use select natural medicines in cases of hepatitis and such related conditions as cirrhosis; alcohol-induced liver disease; substance abuse and addiction; disease-related weight loss and malnutrition. If you know someone with liver problems, please be sure to share this information with them.

# TWO

# Natural Healing Pathways in Hepatitis Therapeutics

"NATURAL THERAPIES CAN BE OF GREAT BENEFIT in treating hepatitis," note authors Michael Murray and Joseph Pizzorno.[2]

"Botanical medicines have been used traditionally by herbalists and indigenous healers worldwide for the prevention and treatment of liver disease," notes a report in *Alternative Medicine Review*.[3] "Clinical research in this century has confirmed the efficacy of several plants in the treatment of liver disease, while basic scientific research has uncovered the mechanisms by which some plants provide their therapeutic effects."

The use of complementary and alternative medicine by U.S. patients with liver disease correlates with the increasing use of complementary and alternative medicine in the general population, according to information provided at a liver disease conference sponsored by the National Institute of Diabetes and Digestive and Kidney Diseases.[4] The August 22-24, 1999 meeting was convened due to the high interest of liver disease patients in such complementary and alternative treatments.

At the conference, Dr. Bruce Bacon (who treated Naomi Judd) noted, "The general public wants access to alterna-

tive medicines, but they also want to know which treatments are helpful and which are carefully regulated for safety and efficacy."

In many ways, the conference was a landmark in complementary therapeutics for persons with hepatitis.

"Treatment of chronic liver disease by conventional means has been a difficult issue, but important therapeutic gains have been achieved in recent years, particularly with regard to chronic viral hepatitis," noted Leonard Seeff, M.D., of the National Institute of Diabetes and Digestive and Kidney Diseases in his introductory remarks at the conference. "Unfortunately, treatment success has been only modest, and adverse effects and discomfort from treatment has been common. Accordingly, many individuals suffering from these conditions have turned to herbal remedies as an alternative or supplement, based on the belief that 'natural' products must be safer and that these products must be useful since many have been available for centuries. Their use is further reinforced by individual testimonies, by widespread internet publicity, and by person-to-person communication."

Yet, noted Dr. Seeff, the medical scientific community has been skeptical about these claims and has tended to either ignore the practice or to disparage the benefit of these products and instead focus on their potential for toxicity. This is wrong and does not serve the patient, he added. "Given the extraordinary widespread use of 'alternative' remedies, the intense faith displays by many users, and by the fact that current 'conventional' treatment is not yet a panacea, it is incumbent on the medical scientific community to give proper consideration to the view and anxieties expressed by the public on this issue."

If you have active hepatitis or cirrhosis, we always want you to work with your doctor. Do not reject mainstream medicine. What we are about to discuss will complement your doctors' mainstream treatments.

Botanicals used as dietary supplements and traditional medicines are consumed for enhancing one's general health, as well as to improve liver function, counteract specific symptoms associated with liver disease, and to ameliorate the side effects of some current therapies, noted Edward M. Croom, Jr., of the Natural Center for Natural Product Research, School of Pharmacy, University of Mississippi, at the conference.

In fact, in the United States, health consumers now have access to over 1,500 species of plants that are sold as dietary supplements with thousands of various formulations that include several plants, minerals, vitamins, glandulars, and other substances. The main activities of these individual plants and formulas include antioxidant, anti-hepatotoxic, anti-inflammatory, antiviral, and immunomodulatory.

Because the use of such formulations can positively or negatively impact the quality of life and course of liver disease, it is critical that we document the range and extent of botanicals and other substances being used and critically evaluate their impact on the health of persons with liver disease.

Among the botanicals and other substances that have been most commonly studied and used are milk thistle, licorice root, *Uncaria gambir*, *hyllanthus amarus*, as well as Traditional Chinese Medicine or Kampo formulations which often include bupleurum root or schizandra fruit, and modern Himalayan formulas.

Our goal is to acquaint you with some of the most important of nature's healers—individual herbs and formulas—that have been clinically validated for their beneficial effects on liver health, particularly hepatitis. We will tell you how to obtain the highest quality materials, should you decide to complement your doctor's mainstream treatments with natural healing therapeutics.

## MILK THISTLE

Milk thistle (*Silybum marianum*), also known as St. Mary's Thistle, is one of the most validated single herbs for liver disease. This stout annual or biennial plant is found in dry rocky soil of southern and western Europe and portions of the United States, including the west coast. Its leaves are green and shiny. They have spiny, scalloped edges with white-streaked veins. During the flowering season from June to August, the flower heads thicken and turn reddish-purple.

Its chemicals include silymarin, which is a mixture of flavonolignans such as silibin, silidianin, and silichristine. It is thought that silibin is the chemical portion of silymarin with the greatest therapeutic value. The plant is widely used in Germany for persons with jaundice and biliary derangements.

### Pharmacology

Much of this herbal medicine's healing power is related to its ability to prevent further liver damage and improve liver function, as well as stimulate cell regeneration so that new cells replace those that are old and damaged.

Often, the liver is damaged from chemical exposures that cause massive releases of oxidizing molecules called free radicals. These damage the liver's cells. Silymarin, the active

chemical in milk thistle, is a potent antioxidant that stops this damage.[5] It also acts as an antagonist to deadly toxins in many experimental liver-damage models; in particular, death cap mushroom poisoning. The therapeutic activity of silymarin is based on two sites or mechanisms. To begin with, it alters the structure of the outer cell membrane of the liver cells (i.e., hepatocytes) in such a way as to prevent penetration of the liver poison into the interior of the cell. Second, it stimulates the action of nucleolar polymerase A, which results in an increase in ribosomal protein synthesis, and thus stimulates the regenerative ability of the liver and the formation of new liver cells.

In one experimental study, administration of silymarin 30 minutes before carbon tetrachloride (CCl4) exposure decreased incidence of liver cell death by 50 percent.[6] The researchers concluded that, "silymarin prevents carbon tetrachloride-induced lipid peroxidation and hepatotoxicity in mice, firstly, by decreasing the metabolic activation of CCl4, and, secondly, by acting as a chain-breaking antioxidant."

In particular, silymarin enhances liver production of a key antioxidant called glutathione (GSH). It can increase the glutathione content of the liver by over 35 percent. Silymarin also enhances levels of another major antioxidant, superoxide dismutase (SOD).[7]

### Clinical Evidence

In a double blind study carried out under standard conditions at two treatment centers silymarin at a dose of 70 mg three times daily, showed a definite therapeutic influence on the characteristic increased serum levels of bilirubin and GOT and GPT enzyme levels associated with acute viral

hepatitis.[8] The above-mentioned values in 28 patients treated with silymarin were compared with those in 29 patients treated with placebo. The laboratory parameters in the silymarin group regressed more than in the placebo group after the fifth day of treatment. The number of patients having attained normal values after three weeks was higher in the silymarin group than the placebo group. As already proved by other investigators, the use of silymarin in acute viral hepatitis can lead to an accelerated regression in abnormal laboratory values, thus validating its use in the treatment of this liver disease.

The effects of silymarin therapy on liver function tests, serum procollagen III peptide level and liver histology were studied in 36 patients with chronic alcoholic liver disease in a six-month, double-blind clinical trial.[9] During silymarin treatment, serum bilirubin, aspartate aminotransferase and alanin-aminotransferase values were normalized, while gamma-glutamyl transferase activity and procollagen III peptide level decreased, thereby reducing risk of further advancing fibrosis. The changes were significant, and there was a significant difference between post-treatment values of the two groups, as well. In the placebo group only gamma-glutamyl transferase values decreased significantly but to a lesser extent than that in the silymarin group. The histological alterations showed an improvement in the silymarin group, while remained unchanged in the placebo group. These results indicate that silymarin exerts hepatoprotective activity and is able to improve liver functions in alcoholic patients.

To determine the effect of silymarin on the outcome of patients with cirrhosis, researchers from the 1st Department of Gastroenterology and Hepatology, University of Vienna,

Austria, conducted a double blind study with 170 cirrhosis patients.[10] Some 87 of the patients received 140 mg silymarin three times daily. Another 83 patients received a placebo. Non-compliant patients and patients who failed to come to their doctor appointments were considered as "drop-outs" and were withdrawn from the study. All patients received the same treatment until the last patient entered had finished two-years of treatment. The mean observation period was 41 months. There were 10 drop-outs in the placebo group and 14 in the treatment group. In the placebo group, 37 patients (plus two of the drop-outs) had died, and in 31 of these, death was related to liver disease. In the treatment group, 24 patients (plus four drop outs) died, and in 18 of these, death was related to liver disease. The 4-year survival rate was about 58 percent in silymarin-treated patients and 39 percent in the placebo group. Analysis of subgroups indicated that treatment with silymarin was effective in patients with alcoholic cirrhosis. No side effects of drug treatment were observed.

## Improved Form of Silymarin

Most recently, Indena, one of the world's leading phytotherapeutic research institutions and suppliers of raw materials to the natural products industry, has developed a new form of silymarin which has a much higher degree of bio-availability. In their research, Indena scientists and associates have learned that silymarin bound to phosphatidylcholine, a key component of the body's cell membranes, is absorbed much better, producing better clinical results. This type of milk thistle is also called *phytosome-bound*.

In a 1990 study, a complex of silybin (i.e., silibin the main active component of silymarin) and phosphatidylcholine or

regular milk thistle was given to nine healthy volunteers.[11] Although absorption was rapid with both preparations, the bioavailability of the silymarin-phosphatidylcholine complex "was much greater than that of [non-phytosome-bound] silymarin, as indicated by higher plasma silybin levels at all sampling times after intake of the complex."

Other studies also confirm superior absorption. A 1991 report in *Planta Medica* notes the active ingredient in Phytosome™-bound milk thistle, silybin, has a bioavailability that "is several-fold greater" than its unbound counterpart. An experimental study, reported on in 1992 in the *European Journal of Drug Metabolism and Pharmacokinetics*, indicates a "superior bioavailability." Clearly, the evidence supports Phytosome™-bound milk thistle extract as the best form now available.

We also know that Phytosome™-bound milk thistle greatly enhances this natural medicine's healing benefits. In a 1992 report in the *Japanese Journal of Pharmacology*, this new compound was compared to ordinary silybin in an animal experiment and was found to be far more effective in preventing liver damage. In fact, it showed a "significant . . . protective activity" against a wide range of assaults on the liver.

Several clinical studies have also verified a greater effect for the silmaryin-phosphatidylcholine complex. Eight patients with chronic viral hepatitis B and/or hepatitis C were given one capsule of the complex daily (equivalent to 140 milligrams of silymarin) between meals for two months.[12] The patients experienced a 36-percent decrease in serum malondialdehyde levels (an indicator of lipid peroxidation), and liver function increased by 15 percent, as indicated by enhanced galactose elimination

capacity. A highly significant reduction in liver enzymes was also observed: AST decreased by 17 percent and ALT by 16 percent.

In yet another study, patients with chronic hepatitis due to viral infection of chronic alcohol intoxication were given the silymarin-phosphatidylcholine complex.[13] Twenty patients received 80 milligrams twice daily, 20 patients 120 milligrams twice daily and 20 patients 120 milligrams three times daily for two weeks. With all dosages, the natural medicine resulted in a marked decrease of average serum and total bilirubin levels. At a dosage of 240 or 360 milligrams daily, there was a highly significant decrease in ALT and GGTP liver enzymes. "These results indicate that even short-term treatment of viral or alcohol-induced hepatitis with relative low doses of phosphatidylcholine-bound silymarin can be effective, but for the best results higher doses are indicated," notes Michael Murray, N.D.[14]

### The Doctors' Prescription

It is important to use extracts standardized for their silymarin content (70 to 210 milligrams). Best results come with higher dosages such as 140 to 210 milligrams of silymarin three times daily.

If possible, use the phosphatidylcholine-bound form of silymarin at a dosage of 100 to 200 milligrams twice daily.

This natural medicine is very safe and without any side effects, complications or drug interactions, as noted in the *PDR for Herbal Medicines*.[15]

### Recommended Formulas

See Resources for a complete listing of supplies of Indena Phytosome™-bound milk thistle formulas.

## LICORICE ROOT

Licorice root (*Glycyrrhiza glabra*) contains glycyrrhizin. In the body, this chemical is metabolized into glycyrrhetinic acid which exhibits profound pharmacological activity, including anti-viral and anti-inflammatory properties, note Melvyn R. Werbach, M.D., and Michael Murray.[16]

Glycyrrhizin is very similar to cortisone in chemical formulation. It has been shown to be effective in clinical trials of acute and chronic liver disease and to inhibit liver cell injury in a series of animal models, notes Dr. Mark A. Zern, of the University of California Medical School, Davis. "A number of studies have suggested that it may have direct and indirect antiviral activities, and a recent report suggests that it may be effective in inhibiting liver carcinogenesis in the treatment of patients with chronic hepatitis C disease." Additionally, glycyrrhizin inhibits collagen overexpression, reducing fibrosis that would otherwise cause extensive scarring and liver damage. It may also profoundly benefit immune function by inducing the body's production of interferon.

Glycyrrhizin has been intravenously used for the treatment of chronic hepatitis B in Japan and improves liver function with occasional complete recovery from hepatitis, note researchers from the Department of Virology, Toyama Medical and Pharmaceutical University, Japan.[17]

In Japan, long-term treatment with intravenously administered glycyrrhizin appears to reduce the progression of chronic hepatitis C and the incidence of liver cancer, noted Dr. TGJ van Rossum of the Department of Hepatogastroenterology, University Hospital Rotterdam, the Netherlands at the 1999 conference. In fact, this natural medicine may be particularly indicated when patients

do not respond with viral clearance to interferon treatment or are unlikely to respond due to cirrhosis or having a particular genetic make-up.

One product that is typically used is called Stronger Neominophagen C (SNMC), which consists of 200 mg of glycyrrhizin, 100 mg of cysteine, and 2,000 mg of glycine. Although many studies call for intravenous administration, it may be equally effective when given orally, as glycyrrhizin is readily absorbed from licorice root in this manner as well.

According to Dr. Murray, "SNMC has demonstrated impressive results in treating chronic hepatitis due to either B or C viruses. With either form, approximately forty percent of patients will have complete resolution—a statistic that compares favorably to alpha-interferon's forty-to-fifty percent clearance rate. Like SNMC, alpha-interferon administration has been shown to lead to dramatic reductions in the risk of getting liver cancer. However, alpha-interferon is expensive and associated with side effects (primarily fever, joint pain, nausea, and flu-like symptoms) in 100 percent of patients."

In a study conducted by Dr. van Rossum and co-investigators, 55 patients with hepatitis C received either placebo, 80 mg or 240 mg of intravenous glycyrrhizin (from Minophagen Company, Tokyo) three times a week or 200 mg of glycyrrhizin six times a week; thus, total dosages for the week ranged from 240 to 1200 mg. Unfortunately, viral clearance was not observed, although therapy was well tolerated and no major adverse events during treatment were observed. On the other hand, the treatment did reduce and normalize ALT levels in a statistically significant number of patients.

*The Doctors' Prescription*

Daily use dosages for the powdered root are one to two grams daily. A fluid extract (1:1) should be taken at a dosage of two to four milliliters daily. A solid (dry powdered) extract (4:1) should be taken at a dosage of 250 to 500 milligrams daily.

**KEY HEALTH ADVISORY:** If licorice root is ingested regularly at about three grams daily for more than six weeks or glycyrrhizin at greater than 100 milligrams daily, there is a possibility for increases in sodium and water retention and elevated blood pressure. This is due to the pseudo-aldosterone action of licorice's components. Thus, persons using licorice root should have their blood pressure monitored regularly as well as their electrolytes and possibly increase their potassium intake.[18, 19]

These effects may be minimized by following a high-potassium, low-sodium diet.[20]

## TRADITIONAL CHINESE MEDICINE

Traditional Chinese Medicine (TCM) also offers aid to persons with hepatitis.

Some of the most thoroughly documented TCM remedies come from Japan, whose health care system has adopted the very best of ancient and esteemed Chinese healing formulas, often applying Western scientific standards to their validation. Some of these products are known by the name Kampo.

After Kampo medicines were approved for use under reimbursement by the National Health Insurance System of Japan in 1976, they have often been prescribed by physicians, notes Jong Chol Cyong, of the Department of Bioregulatory Function, Graduate School of Medicine, University of Tokyo,

Japan. Today, some 70 percent of Japanese physicians use Kampo medicines in their practices. They are frequently utilized in cases of liver disease.

Patients with chronic hepatitis C are in desperate need of treatments to not only alleviate their viral load but to also offset complaints of weakness, loss of appetite, and cold syndrome. It is thought that Kampo medicines can improve these symptoms. Indeed, as Dr. Cyong notes, "We have used these for long-term therapy of patients with chronic hepatitis C (one year to four years) in order to relieve these complaints, and we found decrease or elimination of the virus as well as improvement of the symptoms."

### Shosaikoto (TJ-9)

A formula known as Shosaikoto (TJ-9) combines bupleuri root or Chinese thoroughwax (*Bupleurum falcatum*) with six additional herbs, including licorice root (*Glycyrrihiza glabra*), jujube fruit (*Zizyphus jujuba*), ginger root (*Zingiber officinalis*), *Panax ginseng* root, Chinese skullcap root *Scutellaria baicalensis*) and half summer root (*Pinellia ternata*). The formula exerts anti-inflammatory effects that may protect the liver and may reverse some cases of hepatitis B.[21]

In one study, seven of 14 children with chronic hepatitis B virus (HBV) infection treated with the formula became apparently virus–free in about six months (with a range of about three to nine months), showing no signs of the illness. This healing rate was much better than the 22.7 percent rate among 22 untreated patients.[22]

In a second study, the efficacy of Shosaikoto was studied on 222 patients with chronic active hepatitis in a double-blind multicenter clinical study.[23] Some 116 patients received the TCM formula in a daily oral dose of 5.4 grams

for 12 weeks, followed by the same dose for another 12 weeks. Some 106 patients received a placebo containing 0.5 grams of the TCM formula for 12 weeks, followed by a cross-over to the full formula for a further 12 weeks. Serum AST and ALT values were markedly lower with the active formula. There was a trend of decreased viral presence and an increase of viral antibodies. No side effects were observed.

Drs. Werbach and Murray explain, "Although all of the components of Shosaikoto have exerted anti-inflammatory actions in animal studies, the main action of the formula has been primarily attributed to Bupleuri root's steroid-like molecules known as saikosaponins. However, no pharmacological activity of the root of B. falcatum can be explained by the action of the saikosaponins alone. In addition, other components of Shosaikoto have shown beneficial effects in hepatitis."[24]

## ADDITIONAL TCM REMEDIES

### Ninjin-youmei-to (YJ-108)

Another Kampo medicine, Ninjin-youmei-to (YJ-108) was investigated in experimental cell studies for its inhibition of hepatitis C virus (HCV). "It was found that the formula had the effect of inhibiting reinfection of the cells by HCV," notes Dr. Cyong. "This effect was mainly exerted by *Shisandrae fructus*, which is one of the crude drugs constituting Ninjin-youmei-to."

### Plantago asiatica

Further research has been done on *Plantago asiatica*, also known as psyllium. In this case, an active isolated from its seeds, aucubin A, has been systemically studied and been found to suppress hepatitis B virus replication in experi-

mental cell studies. In a study utilizing woodchucks, when aucubin A was administered to animals infected with the virus, a similar inhibitory effect was found. Based on these experimental studies, a preliminary clinical trial was conducted. Dr. Il-Moo Chang, of the Natural Products Research Institute, Seoul National University, Korea, notes that when a dose of 10 mg/kg (milligrams per kilogram) body weight was infused everyday for a month into eight patients with chronic hepatitis B virus, half of the patients showed a reduction in viral load in their blood samples.

## CH-100

Results for the TCM remedy known as CH-100 have thus far been quite mixed. In one study conducted at the John Hunter Hospital, Newcastle, Sydney, Australia, 32 hepatitis patients received CH-100. Many patients ceased taking the product when it was realized that a cure had not been achieved. After four years of follow-up, only a minority of users of CH-100 maintained normal liver enzymes while remaining on treatment. According to Dr. R. Batey, of the John Hunter Hospital, "The only patients documented to have lost the virus are those who received anti-viral therapy."

However, the CH-100 formulas has been shown to be effective in lowering ALT levels in patients with active hepatitis C, although no patients were actually cured of their viral load. In a second study conducted at the John Hunger Hospital, patients were offered CH-100 therapy if they were unwilling to utilize antiviral therapy or if they had previously failed interferon therapy. Patients were seen monthly and liver function tests were performed prior to provision of another month's supply of the natural medi-

cine. The study analyzed ALT levels in patients who took CH-100 between two and twenty-four months. In 18 patients, ALT levels were reduced, while in nine they were increased. The majority of patients claimed to feel better on CH-100 than they did prior to treatment. However, the results overall were not particularly impressive.

### Synthetic Analog of Schizandra

As mentioned, schizandra has shown particular promise in enhancing the healing response among patients with liver disease. Researchers have developed a synthetic analog of the natural medicine that is called dimethylester biphenyl or DDB. It has been claimed to be very effective in the treatment of hepatitis B and may also be in cases of hepatitis C. Drs. A. El Zayadia and A. Ahdy, from the Cairo Liver Center, Cairo, Egypt, studied the use of DDB among 43 patients with hepatitis C. After one month of treatment, there was marked reduction in ALT and AST levels. Among 21 patients, ALT activity was normalized. Five of eight patients who had not responded to interferon therapy attained normal ALT levels after one month of treatment. There were no side effects reported by the patients. This medicine is particularly promising.

## ARTICHOKE EXTRACT

Artichoke extract is not directly validated to help in hepatitis but is clearly an excellent liver protectant without any complications or drug interactions. Its powerful antioxidant properties make it ideal as a liver-health supplement.

The pharmacology of artichoke extract centers around its affect on the liver. Artichoke extract has been shown to enhance detoxification reactions as well as protect the liver

from damage. This combination of effects is very important to healthy liver function. During detoxification in the liver, the toxic substance is often initially converted to an even more toxic form. Without adequate protection, every time the liver neutralizes a toxin, it is damaged in the process. Artichoke extract has been shown to provide valuable protection during detoxification processes.

Once the liver has modified a toxin, it needs to be eliminated from the body as soon as possible. One of the primary routes of elimination is through the bile. However, when the manufacture of bile is reduced or the secretion of bile is inhibited, toxins stay in the liver (and body) longer. Once again, artichoke extract can help.

The studies show that excellent detoxification results can be expected by using artichoke extract daily alone or in combination with other liver-protective herbs such as milk thistle, licorice and dandelion root.

▲ In one experimental study, liver cell cultures were exposed to toxins such as tert-butylhydroperoxide (t-BHP) or cumene hydroperoxide. These were used to assess the antioxidative and protective potential of water-soluble extracts of artichoke leaves.[25] Both toxins stimulated the production of other chemical toxins including malondialdehyde (MDA), particularly when the cells were pre-treated with diethylmaleate (DEM) in order to diminish the level of the important cellular antioxidant, glutathione (GSH). The addition of artichoke extracts did not affect basal MDA production, but prevented the toxin-induced increase of MDA formation in a concentration-dependent manner when presented simultaneously or prior to the peroxides. The protective potential closely paralleled the reduction in MDA production and largely prevented liver

cell death (necrosis) induced by the toxin's by-products.
The artichoke extracts did not affect the cellular level of
glutathione, but diminished the loss of total GSH and the
cellular leakage of this important antioxidant, resulting
from exposure to t-BHP. Chlorogenic acid and cynarin
accounted for only part of the antioxidative principle of
the extract which was resistant against tryptic digestion,
boiling, acidification, and other treatments, but was
slightly sensitive to alkalinization. These results demon-
strate that artichoke extracts have a marked antioxidative
and protective potential for the liver.

▲ Another study tested artichoke extract for its influence on
sympatho-adrenal system (SAS) activity in experimental
inhalation exposure to carbon disulfide.[26] Activity of SAS
was assessed through excretion of noradrenalin and
adrenalin. Findings indicated a phasic SAS response
depending on concentration and duration of carbon disul-
fide exposure. With exposure to smaller amounts of car-
bon disulfide, SAS activity was observed to decrease in
the second month, followed by increases in the fourth
and sixth months. With exposure to much higher
dosages, SAS activity was elevated over the whole period
of study. Under the influence of the artichoke preparation,
catecholamines, increased by carbon disulfide exposure,
returned to normal. This trend was even more marked for
noradrenalin.

▲ In a human study, 62 men producing artificial fibers in a
toxic work environment were administered artichoke
extract as a preventive for two years.[27] Spontaneous and
ADP-induced platelet aggregation was examined, since
the toxic chemicals to which they were exposed caused
platelet aggregation, which can lead to circulatory dis-

eases. The platelets' ability to aggregate, whether spontaneously or by induction, was found to be statistically significantly reduced. The spontaneous aggregation after two years of administration was reduced on average by 51 percent.

### Dosage Recommendations for Artichoke Extract

We recommend that consumers purchase an artichoke extract standardized to contain 13-18 percent caffeoylquinic acids calculated as chlorogenic acid. Consumers should take one to two 160 to 320 mg capsules three times daily with meals. Formulas from Enzymatic Therapy, PhytoPharmica and Lichtwer Pharma formula meet these standards.

## S-ADENOSYLMETHIONINE (SAMe)

S-Adenosylmethionine (SAMe), newly arrived to the United States, was discovered in Italy in 1952. In the body, it is formed from methionine with adenosyl-triphosphate. Although methionine is found in many foods, it is unlikely that foods would provide a therapeutic dosage.

Clinical studies support use of SAMe in liver disease, including cirrhosis and cholestasis. Studies show that supplementation with SAMe enhances bile flow, improves membrane function and increases levels of the master antioxidant, glutathione.[28, 29, 30]

Because of the risk of liver cancer associated with chronic liver diseases, SAMe may play another important role in that experimental studies have demonstrated significant protection against liver cancer in animals exposed to liver-specific carcinogens.[31]

### The Doctors' Prescription

In liver disorders, the usual therapeutic dosage for SAMe supplementation is 200 to 400 milligrams two to three times daily. No significant side effects have been reported with its use, although persons with bipolar depression should not take SAMe unless under medical supervision, as in limited instances its antidepressant activity may result in a manic phase.

### Special Report: LIV.52/LIVERCARE—WORLD'S MOST THOROUGHLY VALIDATED NATURAL MEDICINE

Although natural medicines such as milk thistle can be extremely beneficial in causes of liver disease, we want to emphasize that the most widely used natural medicine in the world for this condition is a formula known worldwide as **Liv.52®** (and in America as both **Liv.52** when sold professionally at pharmacies or by health professionals and as **LiverCare®** at health food stores and natural product supermarkets). Whether known as Liv.52 or LiverCare, this modern herbal formula has some 284 experimental and clinical studies that support its use in liver disease therapeutics. It is perhaps the world's most thoroughly documented natural liver health formula. We will refer to the formula interchangeably as Liv.52 or LiverCare (in both cases it is the same formula).

Liv.52 was introduced in 1954 as a specially formulated herbal remedy for the treatment of viral hepatitis, which had assumed epidemic proportions in Delhi and other metropolitan cities in India. The remedy was found to be generally useful and has been widely prescribed for infective hepatitis since then.

During the next 46 years, beneficial effects of Liv.52 have been reported in various liver disorders. Experimentally, Liv.52 was demonstrated to prevent injurious effects of car-

bon tetrachloride and other toxic substances on the liver. Clinically, stimulation of appetite and an increase in serum albumin concentration were consistently seen.

The formula is composed of herbs grown in the Himalayas. These herbs are grown without chemical fertilizers or pesticides and then tested for purity and level of active constituent, utilizing thin layer chromatographic fingerprinting. As with all such formulae, the mixture is complex but includes primarily: **capers**, **wild chicory**, **black nightshade**, **arjuna**, **yarrow**, **Negro coffee**, and **tamarisk**.

| **Each tablet of Liv.52 contains:** | |
|---|---|
| *Capparis spinosa* (capers) | 65 mg |
| *Solanum nigrum* (black nightshade) | 32 mg |
| *Cichorium intybus* (wild chicory) | 65 mg |
| *Terminalia arjuna* (arjuna) | 32 mg |
| *Achillea millefolium* (yarrow) | 16 mg |
| *Cassia occidentalis* (Negro coffee) | 16 mg |
| *Tamarix gallica* (tarmarisk) | 16 mg |

Let's look a little more closely at each individual ingredient.

## Capers

*Capparis spinosa* or the caper bush is also known as Himsra and Cabra. Caper bark does not appear to have been used as a medicine in India until introduced by the Mahometans. But its fruits are mentioned in Sanskrit works. Also, it is mentioned in traditional Greek and Latin works. The author of the *Makhzan-el-Adwiya* gives a good description of the plant and mentioned the root bark is the most active part. He considered it to be hot and dry, and to act as a detergent and astringent, expelling cold humors. It was recommended

in dropsy, gouty and rheumatic affections. The fresh plant yields a volatile oil having the properties of garlic oil.

The caper bush is found in Afghanistan, West Asia, Europe, North Africa and Australia. In India it is found throughout the Punjab and Rajesthan to the Deacon Peninsula. A prostrate shrub or climber armed with divaricate light yellow thorns, occurring in dry rocky and stony soils, its leaves are variable in texture with white, solitary flowers.

The cortex and leaves contain stachydrine and 3-hydroxystachydrine. The root contains glucobrassicin, neoglucobrassicin and 4-methoxy-glucobrassicin. The crude extract of the flower buds contains some 162 volatile constituents of which isothiocyanates, thiocyanates, sulphides and their oxidative products have been identified as the major components. The seeds and leaves contain glucocapparin and glucocleomin. The root bark contains stachydrine, rutic acid and a volatile substance with garlic odor.

The plant is credited with antitubercular property. The root bark is extensively used in medicine. The bark is bitter, diuretic, and an expectorant. It is given in spleen, renal, and hepatic complaints. The bruised leaves are applied as a poultice in gout. An extract of the plant as one of the constituents of Liv.52 has shown encouraging results against viral infection in man.

### Wild Chicory

*Cichorium intybus* (Kasani) is an erect, perennial herb with a fleshy tap root. It is native to the temperate regions of the world. Its roots are brownish yellow outside, white within, bark is thin, leaves are broadly oblong, oblanecolate or lanceolate, crowded at the base, forming a rosette arranged spirally on the stems. The part used is the seed, which con-

tains many polyphenolic compounds, mainly flavonoids. The seeds have a carminative action. The decoction of the seeds is used in bilious vomiting. The plant extracts have a liver protective action which may be due to their ability to suppress oxidative damage by free radicals.

This plant has been in use as a pot herb from early times. The ancient Egyptians, Greeks, and Romans used it. Dioscorides mentions two kinds, the wild and the cultivated. The Romans called the plant Intubus or Intubum, and the plural of the latter word has furnished the Arabs with their name Hinduba. Phing called the wild plant *Cichorium*, *Chreston* (useful), *Pancration* (all powerful) and *Ambubara* or *Ambubeia*. It was supposed to be a panacea and to have the property of fixing the affections. The Syrian dancing girls, whom Cneius Manlius first brought to Rome, were also called Ambubaia on account of their attractive allurements. Ambubaia is a Syrian term, but the component parts of it, "Ambui"—"odor" and "Baia"—"full," occur in old Persia. Together they signify—"full of odors," i.e. allurements. According to a German legend, the plant is supposed to have once been a beautiful princess who, having been deserted by (or lost) her husband (or lover), was at her own request changed into this plant. It is much valued by the Indian Hakims as a resolvent and cooling medicine and is prescribed in bilious complaints. Chicory root dried, roasted, and reduced to powder is very extensively used in Europe as a substitute for coffee and for adulterating that article.

An alcoholic extract of the plant was found to be effective against chlorpromazine-induced hepatic damage in adult albino rats. The alcoholic extract of chicory also shows cholagogue (stimulating bile flow) activity which may be attributed to its polyphenols.

The alcoholic extract of the seeds has been reported to cause bradycardia (slow heartbeat) in normal and hypodynamic hearts of frogs, and to elicit a fall in the blood pressure in dogs.

Its seeds were extracted successively with chloroform, methanol and water. All the extracts were subjected to preliminary phytochemical and hepatoprotective screenings in rats against carbon tetrachloride (CCl4) and paracetamol toxicity. The fractions obtained were shown to be hepatoprotective when tested against CCl4- and paracetamol-induced toxicity.

### Black Nightshade

Known as *Solanum nigrum* or black nightshade, this herb has been used from ancient times in Ayurveda along with other ingredients in heart disease. It is also stated that the berries of this plant can be eaten without danger. It appears to have been used chiefly by the Greeks as a local application to quell inflamed bodily tissues. In Persia it was useful in dropsy and as a diuretic. Most Arabian and Persian writers of the *Materia Medica* describe four different kinds.

The plant is effective in the treatment of cirrhosis of the liver. The plant is also credited with emollient, diuretic, antiseptic and laxative properties.

### Arjuna

A large evergreen tree, with a spreading crown and drooping branches, common in most parts of India, the stems of *Terminalia arjuna* (arjuna) are rarely long or are straight, generally buttressed and often fluted. Its bark is very thick, gray or pink or green, smooth, exfoliating in large thin irregular sheets. Its leaves are oblong or elliptic and its flowers are panicled spikes; fruits are nearly glabrous, ovoid, with five to seven

hard-winged angles. The part used is the bark, which contains beta-sitosterol, ellagic acid and arjunic acid. The bark is acrid and credited with syptic, febrigual (anti-fever), and antidysenteric properties. The powdered bark is an effective diuretic and acts as a general tonic in liver disorders. The bark is useful as an anti-ischemic and cardioprotective agent in hypertension and ischemic heart diseases, especially in disturbed cardiac rhythm, angina, or myocardial infarction. The bark powder possesses diuretic, prostaglandin-enhancing and coronary risk factor modulating properties. It apparently has a diuretic and a general tonic effect in cases of cirrhosis of the liver.

### Yarrow

Known as *Achillea millefolium* in Latin, yarrow or milfoil has been used medicinally from an early date. Dioscorides mentions it as a plant which was used as an astringent and emmenagogue. According to Phing, the origin for the generic name for these plants goes back to the mythical figure, Achilles, who made use of the plant as a vulnerary. A species of *Achillea* is the Kaisum of the Arabians. The same plant is the Biranjasib or Biranjasif of the Persians. In Egypt, a species of *Achillea* is used medicinally under the name of Barbara. In Europe and in the East, plants belonging to this genus have long been considered to have stimulant, tonic, emmanogogue and antihemorrhoidal properties. At Engadine, in Switzerland, a volatile oil is extracted from it called Espirt d'Iva. Commonly distributed in the Himalayas from Kashmir to Kumaun, at altitudes of 1,050 to 3,600 meters, it has also been seen growing in the Bombay and Belgaum areas. An erect, slightly aromatic, pubescent, perennial herb with stoloniferous roots, the leaves are oblong and minutely divided; blossoms are in clusters with

white or pale pink flowers; the fruits are oblong, flattened and shining. The herb contains the alkaloid achilline and also yields an essential oil. The herb is considered astringent, tonic, diaphoretic, vulnerary and styphic. It has shown excellent results in the treatment of influenza and heavy chest colds and is much used in blood-purifying compounds.

## Negro Coffee

Also known as *Cassia occidentalis* in Latin and coffee-senna, foetid cassia, Negro-coffee, rubbish cassia, stinking weed, this plant is found throughout India up to an altitude of 1,500 meters. *Cassia occidentalis* is an erect, annual herb or undershrub. The leaves are lanceolate or ovate-lanceolate, the leaflets, three-paired, membranous, glaucous, ovate or lanceolate; the flowers, yellow, in short racemes; the pods, recurved, glabrous and compressed; the seeds, dark olive green, ovoid, compressed, hard, smooth and shining. The seed powder is externally applied in cutaneous diseases and eruptions. The seed is bitter and has tonic, febrifugal and purgative properties. It is considered to be a blood tonic and excellent diuretic. The seeds are useful in cough and whooping cough, convulsions, and in heart disease.

## Tamarisk

Known in Latin as *Tamarix gallica*, tamarisk is found in North India in sandy or gravelly areas, low-lying saline soils and on the banks of rivers. It is a gregarious, bushy shrub or a small tree. The bark is brownish, smooth when young and rough when mature; the leaves are minute, not sheathing; the flowers, pink or white, on long, very slender, spike-like racemes in terminal panicles; the capsules are conical,

trigonous, tapering and pale pink; the seeds, with a plume of white hairs. Its principle constituents include tamarixin along with traces of tamarixetin. Because of its mild and sweet taste, tamarisk is used to move the bowels in children as well as in bleeding disorders like menorrhagia and bleeding of the rectum.

## LIV.52/LIVERCARE—THE COMPLETE FORMULA

The science of natural medicine is subtle and yet very powerful. In the case of a formula such as Liv.52/LiverCare, some herbs enhance action, while others avoid or minimize possible side effects. Plants are complex mixtures of various compounds. One ingredient may be principally responsible for an action, whereas other secondary components may be just as important activators or modifiers of this action. The interaction of a variety of compounds makes remedies safe and more effective. Thus, the formulation derived comprises multiple constituents, which help the formulation to function as a whole.

This particular formula is from The Himalaya Drug Company which combines modern medical technology with traditional herbal medicine. Researchers relentlessly pursue their quest to identify plants with medicinal properties. Often they are successful in, proverbially, turning over a new leaf.

The principles of treatment for various diseases and ailments are well developed. They involve formation of various herbs and minerals in precise proportions with specific processing methods. A careful choice of the right plant by trained personnel is followed by prudent selection of the parts to be processed (i.e., leaves, seeds, stem, bark, or roots). Each step is vital and may produce unsatisfactory pharmacological results when not executed with utmost care.

Quality control processes are very stringent. In essence, once the medicinal herb steps into the lab from nature's lap, it traverses a highly scientific path: pharmacognosy, where its authenticity is established; analytical chemistry where physical and chemical parameters are determined and studied; animal pharmacology where elaborate experimental studies for safety and efficacy are carried out. Stability trials and shelf-life studies are performed. To further confirm purity from pesticides, heavy metals and aflatoxins as well as precise plant constituents, techniques such as high performance liquid chromatography, gas liquid chromatography, high performance thin layer chromatography, and atomic absorption spectrophotometry are used. The product also undergoes Phase I, II, and III clinical studies to establish its safety, tolerability, and efficacy.

## Experimental Evidence

Numerous experimental studies confirm the highly protective effect of the entire formulation on chemically induced toxicity with challenges posed by confirmed hepatotoxins (i.e., liver toxins), including carbon tetrachloride, beryllium, and cadmium.[32, 33, 34] The formula has also been shown to protect against ethanol (alcohol) intoxication, radiation, and chemotherapeutic agents.[35, 36, 37]

## Clinical Validation

The clinical studies that support use of Liv.52 in cases of liver disease date to the 1960s and are as recent as the late 1990s.

We present a sampling of some of the more relevant Liv.52/LiverCare studies that provide evidence for its use as a complementary therapy in treatment of hepatitis and cir-

rhosis, and to mitigate damaging effects of chronic or acute excess consumption of alcohol, which can lead to hepatitis or cirrhosis.

### Hepatitis

STUDY #1. In a study, reported in 1972 in *Probe*, fifty-two cases of viral hepatitis were treated either with the formula or antibiotics and steroids.[38] "In Liv.52 treated cases, improvement in symptomatology was remarkable as compared to the control group," said Dr. G.T. Patel and co-investigators. "After Liv.52 therapy, patients had a subjective sense of well-being and appetite improved in all these cases. Relief from nausea, vomiting, abdominal, constipation and pruritus was rapid."

One-third of patients using the formula experienced weight gain—in contrast to the usual predicted 10 pounds of weight loss during onset of viral hepatitis. This can be attributed to its anabolic effect. In 74 percent of cases, serum bilirubin, which is a good indicator in such cases of degree of jaundice, dropped markedly, as compared to only 28 percent in the control group. What's more, serum alkaline phosphatase, which is a sensitive indicator of bile stasis (lack of bile flow), "remarkably reverted to normal in 63 percent of cases in the Liv.52 series as against 32 percent in [the] control series."

STUDY #2. In a 1976 study, thirty-four patients with infectious hepatitis were divided into two evenly divided groups, receiving either six tablets, daily of the formula or placebo for six weeks.[39] Responses were recorded on days three and seven and thereafter at weekly intervals until a decisive clinical outcome had been reached. Symptoms evaluated

included return of appetite; sense of well-being; degree of jaundice; reduction in size of the liver; and degree of complications. Biochemical parameters studied were serum total bilirubin, serum transaminase and serum alkaline phosphatase. (Among these, it should be mentioned that serum alkaline phosphatase is a more sensitive index of bile stasis than the serum bilirubin level.) Meanwhile, transaminase levels reflect the extent of liver injury and continued elevation would suggest that the disease is not yet resolved.

Among persons in the group receiving the natural medicine, clinical recovery and a 50 percent fall in bilirubin took place in a significantly shorter period; return to normal for serum alkaline phosphatase and transaminase levels was also hastened in the group receiving the natural medicine. There was much higher weight loss or wasting in the placebo group. The formula "helped in ensuring an early recovery from illness."

**STUDY #3.** In a 1977 study published in the *Indian Medical Journal*, fifty patients with infectious hepatitis were enrolled in a controlled study.[40] Almost all suffered with jaundice and dark-colored urine, while other symptoms such as anorexia, nausea, vomiting, constipation, abdominal pain, diarrhea, pruritus, and fever were found in varying degrees in the patients. Among obvious physical symptoms were tender and enlarged liver, palpable spleen, ascites, and edema. One group was given the herbal formula (six tablets daily) together with B-complex vitamins and corticosteroids, while patients in the control group received only B complex vitamins and corticosteroids.

On admission, cases underwent thorough clinical examination and routine laboratory investigations, including total and differential count of white blood cells, stool and urine

examination. Specialized investigation like serum bilirubin, serum alkaline phosphatase, thymol turbidity (which reflects inflammatory activity and complications such as chronic cholestasis [lack of bile flow] and cirrhosis), SGPT and SGOT enzyme tests were also performed in order to assess derangement in liver functions. These were repeated after four weeks and eight weeks of treatment to determine the degree of improvement.

Speedier clinical improvement in the patients receiving the formulation were recorded than in those receiving only the B complex vitamins and medical drugs. **The period required for relief of symptoms and signs was reduced by almost half in the multi-herbal formula group.** As regards liver function tests, a uniform improvement was noted in both groups under study, but the group receiving the multi-herbal formula appeared to improve much more rapidly and completely, as judged from comparative data after four to eight weeks of treatment. A complete return to normal in various liver function tests such as serum alkaline phosphatase, thymol turbidity, SGPT and SGOT values was observed.

STUDY #4. In another report published in *Probe* by Drs. N.L. Patney and A. Kumar, twenty patients with serum B-hepatitis and ranging in age from 25 to 40 were studied.[42] Fourteen received the formula at a daily dosage of two tablets, three times daily and six cases were treated without the formula. In cases receiving the modern multi-herbal formula, the rate of improvement in serum protein ratios, bilirubin, and alkaline phosphatase was much better.

"Patients in the Liv.52 group showed a rapid and progressive improvement in hepatic and biliary metabolism," note Drs. Patney and Kumar. "In the patients of the Liv.52 group,

the amount of albumin, bile salts and bile pigments became less after one month of Liv.52 therapy and was absent after the 2nd month of therapy, as compared to the control group where they became less after the 2nd and 3rd month. The control group showed some improvement after a long period of steroid therapy, but this improvement was very slow in comparison with that in the Liv.52 group."

In conclusion, the comments of G.T. Patel, M.D., and co-investigators of the 1972 *Probe* study are perhaps most apt: "We feel that Liv.52 richly deserves to be used as a routine treatment in all cases of viral hepatitis . . ."

## Treatment of Cirrhosis, Especially due to Hepatitis and Alcohol-induced Liver Disease

Cirrhosis is damage to the liver that results from many different causes. It is one of the great healing challenges persons with liver disease and their doctors will ever encounter. It is also saddening when friends and loved ones develop full-blown cirrhosis and their prognosis becomes bleak. Indeed, when cirrhosis develops as a complication of chronic active hepatitis, the outlook for recovery is usually very poor. About ten percent of persons with hepatitis B and up to 80 percent of some types of hepatitis C cases now develop into chronic viral hepatitis forms with accompanying cirrhosis. By contrast, the outlook for recovery is much better in a heavy drinker with early signs of cirrhosis who stops drinking permanently.

The liver, the largest organ in the body, is essential in keeping the body functioning properly. It removes or neutralizes poisons from the blood, produces immune agents to control infection, and removes germs and bacteria from the blood. It makes proteins that regulate blood clotting and

produces bile to help absorb fats and fat-soluble vitamins. A person cannot live without a functioning liver.

Physicians can prescribe drugs to relieve the symptoms of cirrhosis but these will not reverse the course of the disease. Diuretics can reduce the fluid in the body, and antacids may relieve abdominal discomfort. Vitamin supplements can help in cases of malnutrition. Corticosteroids and immunosuppressive drugs may also be prescribed. Advances in liver transplants have helped to make this procedure another life-saving avenue.

The use of the Liv.52/LiverCare formula as a natural adjuvant to each of these therapies may be critically important. Indeed, if one is to enhance the body's healing response, such medicine may even be considered essential.

### Liv.52/LiverCare Clinical Validation for Cirrhosis

Minimizing the progression of cirrhosis is another key benefit of the Liv.52/LiverCare formula. Let's review some of the key studies.

**STUDY #1.** In a 1979 report in *Current Medical Practices*, researchers from the Institute of Post-graduate Medical Education and Research, Calcutta, India, reported on the Liv.52/LiverCare formula for treatment among some 20 persons with acute hepatic damage and 122 persons with chronic damage manifested as cirrhosis.[43] The study was conducted in three phases.

**Phase I.** Twenty persons with acute hepatic damage were divided into two groups. One group received two tablets of the formula, four times daily, while the other group served as a control. Clinical and biochemical assessment of each person was done initially and at the end of two, four and eight weeks of the study. In this phase, jaundice was reduced by 80 percent in persons receiving the modern herbal formula, whereas

## Liv.52 Results in phase I study (n=20)

| Signs and Symptoms | | Present in (cases) | Improved in (days) |
|---|---|---|---|
| Jaundice | Control | 10 | 17 |
| | Liv.52 | 10 | 10 |
| Anorexia | Control | 10 | 8 |
| | Liv.52 | 10 | 5 |
| Hepatomegaly | Control | 9 | 25 |
| | Liv.52 | 9 | 20 |
| Abdominal distension | Control | 8 | 2 |
| | Liv.52 | 7 | 1 |
| Vomiting | Control | 7 | 3 |
| | Liv.52 | 8 | 3 |
| Fever | Control | 6 | 4 |
| | Liv.52 | 6 | 2 |
| Splenomegaly | Control | 3 | * |
| | Liv.52 | 1 | * |
| Edema (feet) | Control | 2 | 7 |
| | Liv.52 | 3 | 6 |

*No improvement

Mallik, K.K. & Pal, M.B. *Cur. Med. Pract.*, 1979; 23: 5.

only 60 percent improvement was noted in the control group in two weeks duration. Besides jaundice, symptoms of anorexia, fever and hepatomegaly (enlarged liver) were relieved rapidly in the group receiving the modern herbal formula. Two weeks of such therapy also minimized the decrease in serum albumin levels. Transaminase activity was normal in 80 percent of the patients receiving the formula within two weeks and in all cases within four weeks of therapy, whereas only 50 percent of controls recorded normal transaminase activity.

## Liv.52 Scintiscan Results

Figure 1: Liver Scintiscan—Before Liv.52 treatment

Figure 2: Liver Scintiscan—After Liv.52 treatment

Mallik, K.K. & Pal, M.B. *Cur. Med. Pract.*, 1979; 23: 5.

**Phase II.** Studies were done with scintiscan, a process by which the intensity and distribution of radioactivity in tissues is recorded after administration of a small dose of radioactive tracer. Eight cases were studied with scintiscan. Each patient received two tablets, four times daily for three months. Radioactive Rose Bengal I131 liver scintiscan, clinical and biochemical assessment of all the cases was done before and after the therapy. Five (63 percent) out of the

eight cirrhosis cases showed a marked improvement in the total mass of functioning hepatocytes (see figures 1 and 2).

There was marked reduction in cirrhosis symptoms and biochemical improvement, particularly in levels of enzymes, after treatment with the multi-herbal formula. Symptoms of haematemesis, clinical jaundice and signs of hepatic failure disappeared in all of the cases within four weeks of therapy with the formula.

**Phase III.** In this phase, 114 cases were studied. Eighty persons received the usual dosage (two tablets, four times daily) of the Liv.52/LiverCare formula for three months in addition to conventional therapy for cirrhosis. Bromsulphalein (BSP) excretion tests were done in all cases. The remaining 34 patients served as controls and received only conventional treatment for their cirrhosis.

Decreased accumulation of serous fluid in the membrane lining the abdominal cavity, swelling in the feet and lessening of prominent abdominal veins was observed in the group given the multi-herbal formula, as compared to the controls. Biochemically, there was significant improvement in transaminase levels and BSP clearance in the group receiving the formula.

**STUDY #2.** In another 1979 report published in *Probe*, the formula was studied in management of various stages, severity and activity of infective hepatitis and portal cirrhosis (a condition affecting the transverse fissure of the liver and causing portal hypertension).[44]

A total of 66 cases were included in the study. A thorough clinical examination including history, clinical features of liver cell insufficiency and portal hypertension was made in each case. A complete blood examination, liver function

tests and relevant enzymatic studies were conducted.

After classification of the cases according to stages of severity of the underlying liver disorders, they were randomly allotted on the following treatment schedules:

Group I received two tablets, three times daily of the formula. Group II received two tablets, three times daily of the formula, plus the usual supportive treatment consisting of vitamins, glucose and steroids. Group III received only supportive therapy. Group IV received only placebo therapy.

The researchers found that the addition of the multi-herbal formula "displays a marvelous beneficial effect clinically in the form of lessening of jaundice and itching, marked subjective feeling of well-being, recovery in appetite, gain in weight and lessening of dyspepsia, flatulence, nausea, etc."

In cases of uncomplicated infective hepatitis, a greater improvement in liver function test and enzymes was observed in Groups I and II as compared to Groups III and IV. The improvement in Group II was greater than in Group I (demonstrating the value of the Liv. 52/LiverCare formula as a complementary therapy). While comparing Group II with Group III, Group II again showed a better and quicker recovery in clinical and biochemical parameters.

In cases of chronic hepatitis, a better response to the therapy was seen in Group II receiving the full benefits of complementary therapy, as compared to Groups III and IV.

The formula is a "safe and effective" therapy "in the treatment of uncomplicated cases of infective hepatitis and portal cirrhosis as well as cases with... cholestasis," said the researchers. "[Liv.52/LiverCare] not only helped improving the liver function tests, but also expedited the recovery. [Liv.52/LiverCare] therapy showed a satisfactory response

when used alone in the treatment of uncomplicated and infective hepatitis. In other complicated disorders including hepatic cirrhosis... expedited the recovery when used in combination with steroids and has been shown as a useful adjunct in the treatment of these conditions."

**STUDY #3.** The most dramatic evidence of the healing benefits of the Liv.52/LiverCare formula were shown in a 1983 study with 104 persons with infectious hepatitis, chronic active hepatitis and cirrhosis of the liver.[45] Seventy-three persons were treated with the formula and received four tablets, three times daily, and 31 were given standard treatment without the formula (which included rest, nutritious diet, and vitamin supplements). Bromsulphalein excretion tests were performed among 20 patients with chronic active hepatitis and cirrhosis including 10 using the formula and 10 who were not. Hepatitis B antigen (HbsAg) was tested in all cases. Periodic liver biopsy was done in patients of each clinical category, except in infective hepatitis.

In patients with infective hepatitis, a symptomatic improvement in the group receiving the natural medicine was observed especially in respect to fever, anorexia, nausea, weakness headache and stomach pain, as compared to the control group. Disappearance of jaundice and an improvement in physical signs such as resolution of tender liver was observed in the group receiving the formula. The biochemical profile also showed an early improvement in the group receiving the formula.

In patients with chronic active hepatitis, an early clinical improvement in respect to fever, anorexia, high colored urine, weight loss, and jaundice was noticed in a majority of cases receiving the multi-herbal formula, as compared to the con-

## Photomicrographis of needle biopsies of liver performed before and after treatment with Liv.52/LiverCare in cirrhosis

Pre-treatment

Post-treatment
(9 to 12 months' time)

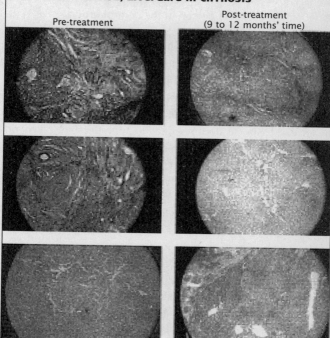

Photographic/histopathological investigations revealed that nine cases in the group receiving the natural medicine showed marked improvement with respect to regeneration and repair of liver cells within six months, whereas none in the control group showed a significant change during the same period. Note also the almost complete lack of fibrosis in the post-treatment group.

Mandal, J.N. & Roy, B.K. Medical College & Hospital, Calcutta, India. *Probe*, 1983; XXII(4): 217.

trol group. Serum alkaline phosphatase level was reduced significantly. After twelve months, there was a marked clearance in BSP in all five of the patients receiving the natural medicine, and in only one person in the control group.

The photographic/histopathological investigations revealed that nine cases in the group receiving the natural medicine showed marked improvement with respect to regeneration and repair of liver cells within six months, whereas none in the control group showed a significant change during the same period (see photographs, page 83).

An early clinical improvement in four persons receiving the formula was observed in 12 months' time and in another 10 in 24 months' time, as compared to the control group. Serum alkaline phosphatase levels decreased dramatically, as compared to the control group. Of the five total cases receiving the formula and whose BSP was measured, four showed greater excretion of BSP in 12 to 18 months as against only one case in the control group. Additional photographic examination revealed that four cases receiving the formula showed remarkable improvement in 12 months, their photographs showing almost total normal liver architecture with minimal fibrosis and no progress in fibrosis and remained so until 24 months later, while in the control group the fibrosis was progressive (see photographs, page 83).

The researchers concluded that treatment with the formula was highly encouraging as a good palliative, if not a curative.

STUDY #4. Encouraged by the excellent results obtained in adult cirrhosis of the liver when treated over a prolonged period with Liv.52 and also their own findings of the natural medicine's usefulness in infective hepatitis, Drs. Mehrota and Tandan decided to see the effects of Liv.52 in adult cases of cirrhosis.[46]

A trial of Liv.52 was carried out in 40 adult cases of cirrhosis to assess its therapeutic response. It was used in complementary fashion in addition to routine treatment. A detailed history of each patient included in the trial was taken. Presenting symptoms and signs were noted after a thorough clinical examination.

These 40 cases were put on a mercurial diuretic and a standard salt-restricted hospital diet. They were divided into two groups (A and B), the former comprised of 25 cases and the latter of 15. Group A cases were given eight tablets of Liv.52 in the dose of four tablets, twice daily for six weeks. Liver function tests were performed before beginning the therapy and after completion of six weeks therapy.

The common presenting signs and symptoms were anorexia in 40 cases; splenomegaly in 38 cases; weakness in 38 cases; flatulence and abdominal discomfort in 33 cases; feeling of lethargy in 30 cases; nausea in 28 cases, jaundice in 11 cases; hepatomegaly in 10 cases; and haematemesis (excess blood accumulation) in 3 cases (see Tables 1 and 2).

### Table 1: Common presenting symptoms

| Symptom | No. of cases |
|---|---|
| Anorexia | 40 |
| Weakness | 38 |
| Abdominal discomfort and flatulence | 33 |
| Feeling of lethargy | 30 |
| Nausea | 28 |

Mehrotra, M.P. & Tandan, S. "Liv. 52, a clinico-biochemical trial in hepatic cirrhosis." *Current Medical Practices*, 1973; 17(4): 185-188.

## Table 2: Common presenting signs

| Signs | No. of cases |
|---|---|
| Splenomegaly | 38 |
| Jaundice | 11 |
| Hepatomegaly | 10 |
| Haematemesis | 3 |

Mehrotra, M.P. & Tandan, S. "Liv. 52, a clinico-biochemical trial in hepatic cirrhosis." *Current Medical Practices*, 1973; 17(4): 185-188.

In group A, an improvement in the general condition of 20 cases was noted after two weeks of therapy and in three cases after four weeks while the condition of two cases remained unchanged at the end of six weeks. In group B, four cases improved in two weeks and another five cases improved on completion of six weeks but the condition of six cases remained unchanged.

Lack of appetite (anorexia) disappeared within two weeks of Liv.52 therapy in 19 cases of group A and after completion of six weeks of therapy in five cases. Only one case in this group still complained of anorexia. In group B, five cases regained appetite within four weeks of treatment and two cases after six weeks of therapy; eight cases complained of anorexia after completion of trial.

Twenty cases in group A complained of flatulence and abdominal discomfort, of which 14 cases improved within two weeks and on completion of six weeks only one case still complained of this symptom. In group B, out of 13 cases four improved within two weeks and another three after completion of six weeks treatment. Six patients continued to complain of flatulence and abdominal discomfort.

## Table 3: Response observed in signs & symptoms in the Liv.52 group & Control group

| | | Total cases | 2nd week | 4th week | 6th week | Total responses | % |
|---|---|---|---|---|---|---|---|
| General well being | Liv.52 | 25 | 20 | 3 | – | 23 | 92.0 |
| | Control | 15 | 4 | – | 5 | 9 | 60.0 |
| Anorexia | Liv.52 | 25 | 19 | – | 5 | 25 | 96.0 |
| | Control | 15 | – | 5 | 2 | 7 | 46.0 |
| Abdominal discomfort & flatulence | Liv.52 | 20 | 14 | – | I5 | 19 | 95.0 |
| | Control | 13 | 4 | – | 3 | 7 | 53.8 |
| Feeling of lethargy | Liv.52 | 19 | 12 | – | 7 | 19 | 100.0 |
| | Control | 11 | 3 | – | 2 | 5 | 45.5 |
| Nausea | Liv.52 | 18 | 10 | – | 8 | 18 | 100.0 |
| | Control | 10 | 2 | – | 3 | 5 | 50.0 |
| Spleno-megaly | Liv.52 | 24 | – | – | 3 | 3 | 12.5 |
| | Control | 14 | – | – | – | 0 | 00.0* |
| Jaundice | Liv.52 | 9 | – | – | 6 | 6 | 66.7 |
| | Control | 3 | – | – | 1 | 1 | 33.33 |
| Hepato-megaly | Liv.52 | 6 | – | – | 3 | 3 | 50.0 |
| | Control | 4 | – | – | – | 0 | 00.0 |

*3 cases showed increase in size by 1" to 2".

Mehrotra, M.P. & Tandan, S. "Liv. 52, a clinico-biochemical trial in hepatic cirrhosis." *Current Medical Practices*, 1973; 17(4): 185-188.

A feeling of lethargy was complained of by 19 patients in group A and of these 12 cases improved in two weeks and the remaining after six weeks of therapy. In group B of the eleven cases, three improved within two weeks while two improved on completion of six weeks and six cases continued to complain of a feeling of lethargy.

Of the 18 cases complaining of nausea in group A, 10 improved after two weeks therapy and the rest after completion of six weeks. In group B of the 10 cases, two improved after two weeks therapy and another three after completion of six weeks and in the remaining five cases no improvement was observed.

In three cases of group A, slight regression in size of spleen was noted (less than two inches without haematemesis) while in the remaining 21 cases no significant change in the size of the spleen was found. In group B of the 14 cases with splenomegaly, 11 cases did not show any appreciable change in size, while in three cases the size of the spleen increased by one to two inches.

In group A, nine cases presented with jaundice out of which six cases were relieved within six weeks and in three cases jaundice persisted. In group B, three cases presented with mild jaundice, which disappeared in one case and remained unchanged in two cases.

In group A hepatomegaly was seen in six cases. After six weeks of trial, the liver regressed in three cases, while in three cases the size remained unchanged. In group B all the

### Table 4: Improvement in serum protein and albumin levels

|  | Increase in gm% | No. of cases in Liv.52 Group A | No. of cases in Control Group B |
|---|---|---|---|
| Serum protein | 1.5 to 2.5 | 3 | Nil |
|  | 0.5 to 1.5 | 5 | Nil |
| Serum albumin | 1.0 to 1.5 | 5 | Nil |
|  | 0.5 to 1.0 | 4 | 3 |

Mehrotra, M.P. & Tandan, S. "Liv. 52, a clinico-biochemical trial in hepatic cirrhosis." *Current Medical Practices*, 1973; 17(4): 185-188.

four cases with hepatomegaly did not show any change on the completion of six weeks trial (see Table 3).

**BIOCHEMICAL STUDIES AND OBSERVATIONS.** In group A, an improvement in total serum proteins was observed in eight cases. In three cases the serum proteins increased in the range 1.5 to 2.5 gm% while five cases improved in the range of 0.5 to 1.5 gm%. In group B total serum proteins level remained unchanged after a period of six weeks (see Table 4).

In group A serum albumin increased in the range of 1 to 1.5 gm% in five cases while in four cases these levels improved to 0.5 to 1 gm%. The rest of the cases did not show any significant change. Serum albumin level in group B improved in only three cases by 0.5 to 1 gm% (see Table 4).

| Table 5: Improvement in other liver function tests | | | |
|---|---|---|---|
| | *Fall in* | *No. of cases Liv.52 Group A* | *No. of cases Control Group B* |
| Thymol turbidity | To normal | 2 | Nil |
| | Appreciable fall of 5 to 10 units | 8 | Nil |
| | Slight improvement | 6 | Nil |
| Thymol flocculation | To normal | 2 | 1 |
| | +++ to + | 4 | Nil |
| | ++ to + | 6 | Nil |
| Zinc sulphate turbidity | To normal | 3 | Nil |
| | Fall of 10 to 15 units | 7 | Nil |
| Serume alkaline phosphatase | To normal | 4 | 3 |
| | Fall of 13 to 15 units | 3 | Nil |

Mehrotra, M.P. & Tandan, S. "Liv. 52, a clinico-biochemical trial in hepatic cirrhosis." *Current Medical Practices*, 1973; 17(4): 185-188.

In group A thymol turbidity came down to normal in two cases and fell appreciably lower in another eight cases. Slight improvement was noted in another six cases. It was observed that Liv.52 is helpful in lowering the thymol turbidity in these cases. Thymol turbidity did not show any appreciable change in group B (see Table 5).

In the two study, group A thymol flocculation became negative in two cases while in four cases it fell from +++ to + and in six cases from ++ to +, showing an appreciable improvement in the function of liver after the completion of therapy. In group B, cases thymol flocculation became negative in one case while in the rest it remained unchanged (see Table 5).

In the study, group A zinc sulphate turbidity reverted back to normal in three cases, while in another seven cases it fell appreciably. In group B, zinc sulphate turbidity did not show any appreciable change after the completion of the six-week trial period (see Table 5).

In the study, group A serum alkaline phosphatase fell within normal limits in four cases while it came down appreciably in another three cases. In the rest it did not show any remarkable change. In the patients of group B, serum alkaline phosphatase reverted back to normal in three cases and in the remaining did not change appreciably.

Another remarkable feature observed was that patients receiving Liv.52 not only showed a clinical improvement along with liver functions but also had an appreciable rise in hemoglobin percentage. In group A, hemoglobin improved in 16 cases. In three cases no significant improvement was found. In contrast to this in group B, hemoglobin improved in six cases (see Table 6).

## Table 6: Improvement in hemoglobin percentage

| Increase in hemoglobin | Liv.52 Group A | Control Group B |
|---|---|---|
| More than 4 gm % | 6 | nil |
| 3 to 4 gm % | 3 | nil |
| 2 to 3 gm % | 2 | 3 |
| 1 to 2 gm % | 5 | 3 |
| 0.5 to 1 gm % | 5 | – |

Mehrotra, M.P. & Tandan, S. "Liv. 52, a clinico-biochemical trial in hepatic cirrhosis." *Current Medical Practices*, 1973; 17(4): 185-188.

The researchers note, "Observations during this trial have led us to believe that Liv.52 (an indigenous drug) acts promptly in improving the general condition, anorexia, flatulence, abdominal discomfort, nausea and lethargy. It probably also helps in the regression of liver but has no appreciable effect on the size of the spleen."

They concluded that, "Liv.52 therapy tends to improve liver functions in hepatic cirrhosis. A rise in total serum proteins and its albumin content were observed. Thymol turbidity, thymol flocculation and zinc sulphate turbidity tests also showed an improvement. Serum bilirubin showed a fall."

Although the trial period of six weeks was short, it established that Liv.52 helps to correct liver dysfunction, suggesting that prolonged therapy might be an answer for cirrhosis patients seeking an improvement in their overall health.

### Children and Hepatitis

STUDY #1. In a report in *Current Medical Practices*, the formula was used among 100 cases of viral hepatitis with patients ranging in age from two to twelve years.[47] There were 59 males and 41 females. Enlarged liver was the most outstanding feature in 95 cases with tender liver in 76 cases.

Elevation of serum bilirubin provided an accurate indication of the severity of jaundice and helped in determining the progress of jaundice.

The jaundice in these patients cleared much earlier than expected typically with fewer or no complications and appetite returned to normal. The course of the disease was uneventful; convalescence was more rapid; and there was quicker recuperation of the liver. There was a sense of well-being and the liver function tests and blood bilirubin studies suggested an early response and improvement; the average number of days of jaundice was much less than in the non-treated group. Pruritus was also significantly relieved and liver size and tenderness decreased. Digestive function improved.

Laboratory findings of serum bilirubin, serum alkaline phosphatase levels and SGOT and SGPT enzyme levels also showed an earlier return to normal. Cases with edema and or ascites probably also suffered subacute liver necrosis and though they went through a "stormy course," they eventually recovered.

STUDY #2. A comparative study was conducted in 30 children below the age of three years who suffered from infectious hepatitis.[48] Complaints included jaundice, loss of appetite, high colored urine, nausea and vomiting. Fourteen children received the formula (delivered as syrup or tablets) while 16 received placebo. The children receiving the formula showed a significant improvement in their clinical condition after the first week of treatment. There was a marked reduction in their symptoms by the end of the second week as compared to those receiving placebo. Liver function tests returned to normal much earlier when compared to the children receiving placebo.

## HOW THE LIV.52/LIVERCARE FORMULA WORKS

The anabolic effect of this multi-herbal formula is discernible in the improvement of general well-being and appetite and in the relief of nausea, vomiting, and malaise. The control of abdominal pain and hepatic tenderness is presumably the result of the anti-inflammatory effect of the medicine. Constipation in infected patients is partly the result of inadequate intake of food due to the deficiency of bile salts which are known stimulants of peristalsis. The relief of constipation appears partly to be the result of choleretic action of the formula and partly of the increased food intake in response to improved appetite. The formula improves the function of liver cells and promotes regeneration of damaged and dying cells, thereby improving protein synthesis. The diminution of enzyme activity consequent to therapy is an indication of inhibition of both cell necrosis, as well as inflammation. The formula is experimentally proven to aid in liver cell regeneration and to offer a significant protective effect from chemical assault and biological assaults on the liver. It's an important formula for anyone with liver disease, particularly hepatitis or cirrhosis, or who wishes to prevent the condition.

### SPECIAL REPORT*

*Liver Help for Alcohol Abuse*

Alcohol use is widespread in the United States—although per capita consumption has varied from decade to decade. In fact, although consumption of alcoholic beverages increased after World II, it has declined slightly since 1981.

But even with declines in alcohol use, two of three American adults drink alcoholic beverages, and about half of all alcohol consumed in this country is ingested by heavy drinkers, esti-

*This special report contains its own set of numbered references (see page 101).

mated to be between 6.5 and 10 percent of the total population. The extent and frequency with which these individuals drink cause serious health and behavioral problems—disrupting their own lives and that of their family, friends, and employers—and also extracts a heavy societal toll. Alcohol use is involved in:

▲ One-half of all murders, accidental deaths, and suicides.
▲ One-third of all drownings and boating and aviation deaths.
▲ One-half of all crimes.
▲ Almost half of all fatal automobile accidents.

The health problems associated with alcohol abuse include brain damage, cancer, heart disease, and cirrhosis of the liver.

### How Alcohol Works in the Body

Although this publication does not advocate or encourage alcohol consumption, it is known that temperate and occasional users of alcohol who are in normal health do not appear to suffer negative effects from use of alcohol. In moderate doses, alcohol has beneficial effects on relaxation, appetite stimulation, creation of a mild sense of euphoria, and with possible beneficial effects on circulatory and cardiovascular health. However, even one episode of binge drinking can cause permanent bodily damage.

Consumed in substantial amounts over time or compressed into one episode of binge drinking, alcohol becomes a poison, a foreign substance in the body's metabolism. The short-term expression of this toxicity is felt as a hangover. The long-term toxicity may develop into alcoholism and alcohol-related diseases such as cirrhosis or hepatitis.

Most foods are prepared for digestion by the stomach so that their nutrients can be absorbed by the large intestine, but 95 percent of alcohol is absorbed directly through the stomach wall or the walls of the duodenum and the small intestine.

Alcohol moves from the bloodstream into every part of the body that contains water, including major organs like the brain, lungs, kidneys, and heart, and distributes itself equally both inside and outside of cells. Only five percent of alcohol is eliminated from the body through the breath, urine, or sweat; the rest is oxidized or broken down in the liver. In the liver, alcohol is broken down in steps by enzymes until only carbon dioxide and water remain as by-products.

## Physical Effects of Alcohol Abuse

Since alcohol so easily permeates every cell and organ of the body, the physical effects of chronic alcohol abuse are wide-ranging and complex. Large doses of alcohol invade the body's fluids and interfere with metabolism in every cell. Alcohol damages the liver, central nervous system, gastrointestinal tract, and heart. Alcoholics who do not quit drinking decrease life expectancy by 10 to 15 years.

The liver breaks down alcohol in the body and is therefore the chief site of alcohol damage. Liver damage may occur in three irreversible stages:

**FATTY LIVER.** Liver cells are infiltrated with abnormal fatty tissue, enlarging the liver.

**ALCOHOLIC HEPATITIS.** Liver cells swell, become inflamed, and die, causing blockage with a mortality rate between 10 and 30 percent.

**CIRRHOSIS.** Fibrous scar tissue forms in place of healthy cells, obstructing the flow of blood through the liver. Various functions of the liver deteriorate with often fatal results. About 10 percent of alcoholics develop cirrhosis.

A diseased liver cannot convert stored glycogen into glucose, thus lowering blood sugar and producing hypoglycemia; inefficiently detoxifies the bloodstream and inadequately eliminates drugs, alcohol, and dead red blood cells; cannot manufacture bile (for fat digestion), prothrombin (for blood clotting and bruise prevention), and albumin (for maintaining healthy cells).

Alcohol in the liver also alters the production of digestive enzymes, preventing the absorption of fats and proteins and decreasing the absorption of the vitamins A, D, E, and K. The decreased production of enzymes also causes diarrhea.

### Liv.52/LiverCare Formula Aids Alcoholic Liver Regeneration

Substantial scientific evidence supports use of Liv.52/LiverCare among persons with a history of alcohol abuse or for protection when persons use too much alcohol on a single night of partying or are prone to binge drinking.

### Experimental Evidence

A study published in a 1988 issue of Probe notes that even a single episode of social drinking causes reversible impaired liver function. However, in an experimental study treatment with Liv.52/LiverCare protects the liver from alcohol-induced injury.[1]

Ethanol administration resulted in a significant increase in serum cholesterol, hepatic cholesterol and decrease in liver glycogen compared to the control group, thus producing classic symptoms of liver damage. Simultaneous treatment with Liv.52/LiverCare, however, restored serum and liver cholesterol levels to near normal. Microscopic examination of liver tissues revealed fibrosis and fatty liver in the group receiving ethanol. These changes were reversed in liver sections in the

experimental group receiving Liv.52/LiverCare. Many additional experimental studies validate these findings.[2, 3]

### Clinical Evidence

Clinical studies support use of Liv.52/LiverCare among heavy drinkers and for enhanced elimination of alcohol body burdens; persons with liver cirrhosis; and for reducing hang-over.

**PROTECTS LIVER IN CASES OF HEAVY DRINKING.** In a 1977 study, 20 male heavy drinkers aged between 45 and 55 with a mean duration of alcohol intake of five years were evaluated clinically and with routine laboratory investigation including liver function tests for assessing the severity of their liver damage.[4] Diagnosis of incipient or overt cirrhosis was based on the presence of an enlarged, firm liver and liver function tests. Patients were instructed to abstain from alcohol or smoking for at least one week before and during the study. The patients were advised to take two tablets of Liv.52/LiverCare, three times daily for six weeks. Investigations were repeated at the third and six weeks. After six weeks of treatment with the herbal preparation, patients using the formula reported an enhanced sense of well-being and an increased appetite. A significant rise in total protein and serum albumin occurred. An improvement was observed in liver function tests, especially gamma glutamic transpeptidase (GGTP) levels, which are specific for alcoholic hepatitis.

"Liv.52 prevents the progress of liver cirrhosis by inhibiting the toxic effects of acetaldehyde," note the researchers. "The rise in serum albumin and increase in plasma volume may restore hepatic blood flow and relieve anoxaemia [oxygen deficit]. This dual action of Liv.52 may arrest or even reserve the course of alcoholic liver cirrhosis. Liv.52 also exerts a pro-

tective action on the liver as indicated by a significant reduction in the levels of SGOT, SGPT, bilirubin and GGTP."

**INCREASES ELIMINATION OF ALCOHOL.** Although the bioavailability of ethanol varies from beverage to beverage, increased levels of an intermediary metabolite of ethanol, acetaldehyde, result from imbibing virtually all types of alcoholic beverages. Recent studies indicate that acetaldehyde may be responsible for the liver damage associated with chronic alcoholism. In addition, acetaldehyde produces the anorexia characteristic of alcoholics and reduces albumin synthesis, thus leading to cell damage and death. Therefore, the key to prevention of liver disease and other related symptoms is associated with acetaldehyde metabolism. If you're going to drink, Liv.52/LiverCare can offer protection.

Chronic social users of alcohol with normal liver function participated in this 1992 study.[5] Blood alcohol and acetaldehyde levels were estimated after a fixed intake of different beverages, before and after two weeks of treatment with Liv.52/LiverCare.

It was observed that Liv.52/LiverCare treatment caused an initial increase in the blood ethanol levels, but, subsequently, liver metabolism of ethanol was enhanced. In the first hour after ingestion of alcohol there was an increase in acetaldehyde levels and subsequent rapid decline, causing significant lower levels. This rapid decline was due to increased excretion in the urine.

The formula prevents binding of acetaldehyde, the intermediately metabolite of ethanol, to cell proteins, causing initial higher blood concentrations and rapid excretion in the urine, leading to a rapid decline in the blood levels.

**IMPROVES PATIENTS WITH ALCOHOLIC CIRRHOSIS.** In a 1995 report, the effect of treatment with the herbal preparation was investigated in a well-controlled study. Twelve patients with well-documented alcoholic liver cirrhosis who had been abstinent in the last two months before the study were treated with three tablets of Liv.52/LiverCare, four times daily or placebo over 12 weeks. Their liver function was investigated by various quantitative liver function tests. During therapy with Liv.52/LiverCare all test results improved compared to placebo.

**HANGOVER** Hangover is a withdrawal state. If you medicate this withdrawal with more alcohol, the alcohol will continue to circulate in the blood and will not be completely eliminated. Taking amphetamines (uppers) merely masks hangover symptoms. The best hangover cure is aspirin, liquids, sleep, and time. Bland foods, especially liquids, may also help. The best prevention for a hangover is moderation or abstinence.

---

### A HANGOVER IS A COMBINATION OF PHYSICAL SYMPTOMS:

▲ Headache: Blood vessels in the head, dilated by alcohol, painfully stretch as they return to their normal state.
▲ Upset stomach: Alcohol irritates the gastric lining, leading to acute gastritis.
▲ Dehydration: Alcohol acts as a diuretic, stimulating the kidneys to process and pass more water than is ingested.

---

In a study with the Liv.52/LiverCare formula, 20 healthy men between the ages of 35 to 50 years of age who were moderate consumers of alcoholic beverages for the past three to fifteen years volunteered for a study on the protective effect of the herbal formula against hangover.[7] Each person was

advised not to consume alcoholic beverages for three days prior to the study. Participants were given 30 milliliters of whiskey with soda and ice or lime juice with soda and ice every 30 minutes for five doses. Wafers, boiled eggs and cheese were allowed. Two hours after the last dose, liver function tests were performed and the participants went to sleep.

At seven a.m. the following morning, the participants were given a questionnaire to assess the effect of alcohol ingestion and were told to mark on a scale their subjective feeling of depression and hangover.

Next, the participants were then given either Liv.52/Liver-Care tablets or placebo tablets according to a random allocation at a dose of two tablets, three times a day for 15 days. During the first 12 days, participants were allowed to consume alcoholic beverages as usual. The study was repeated.

A newly developed method using radio-iodinated Rose Began has proved to be a very sensitive and accurate test for liver cell function. It was found that consumption of whiskey produced a significant decrease in hepatic extraction of the dye. Treatment with the herbal preparation prevented this decline in function. Meanwhile, on the subjective side, the symptoms of hangover were noticed when whisky was consumed, but the score was much lower in patients receiving the herbal preparation. The researchers commented, "Though the values do not show statistical significance, it is obvious that subjects treated with Liv.52 had less signs of hangover. Thus, at least part of the symptoms of hangover may be due to impairment of liver functions by alcohol."

Liv.52/LiverCare will work better if the following steps are followed:

**Stop the deadly spiral.** In cases of substance abuse, the first step is to stop using the substance in question, whether

it is alcohol or street drugs. This may require intervention by family or friends. It may be difficult to intervene, but such an act may save someone's life.

**Professional counseling and support groups are often beneficial.** Many support groups can be found in every community. These may not be for everyone but they have helped many people stay sober.

**Nutritional support is essential.** In cases of substance abuse, it is likely that the body has been deprived of optimal intake of many nutrients. Thus, a balanced multiple vitamin and mineral formula is important, as well as improved diet.

**Liver support, in particular, is critical.** Clearly, Liv.52/LiverCare is a formula whose ability to benefit persons whose liver function is damaged by alcohol abuse is well documented. In extreme cases, take two tablets, three to four times daily.

**Liver protection is critical**. As this formula is protective against alcohol's acute effects and protective against environmental pollutants that may damage the liver (including heavy metals), take one or two tablets, twice daily, as a preventive.

### References

1  Subbarao, V.V. "Effect of Liv.52 against alcohol-induced hepatic damage—a biochemical study." *Probe*, 1976; XV(4): 235.

2  Prasad, G.C. "Electron microscopic study of the liver after prolonged use of alcohol." *Probe*, 1980; XIX(3): 179.

3  Gopumadhavan, S., et al. "Protective effect of Liv.52 on alcohol-induced fetotoxicity." *Alcoholism: Clin. & Exp. Res.*, 1993; 17(4): 1089.

4  Dubey, G.P., et al. :Liv.52 in alcoholic cirrhosis, pre-cirrhotic and early cirrhotic conditions. Effect of Liv.52 on different biochemical parameters in alcoholic cirrhosis." *The Antiseptic*, 1977; 91(6): 205.

5  Kularni, R.D. "Alcoholic liver disease—the possibility of Ayurvedic therapy." *J. Gen. Med.*, 1992; 4(2): 11.

6  Lotterer, E. & Etzel, R. "Liv.52 in patients with alcoholic liver cirrhosis—pilot study of a controlled clinical trial." *Forsch Komplementärmed*, 1995; 2: 12.

7  Kulkarni, R.D. "Effect of ethanol on liver function and its relation to hangover: protective effect of Liv.52." *Probe*, XX;4: 272-275.

## THE DOCTORS' PRESCRIPTION

In the case of Liv. 52/LiverCare, both acute and chronic toxicity studies, as well as studies on use during pregnancy, confirm its freedom from adverse effects or drug interactions.[49, 50]

Additional reports from medical doctors and other health experts further confirm the excellent benefits of the Liv.52/LiverCare formula in patients with hepatitis, cirrhosis and other aspects of liver disease. Francis Eugene Seale, M.D., of Kerrville, Texas, has used the Liv.52/LiverCare formula consistently in his practice treating substance abuse patients. "We found the formula improved liver enzymes and overall well-being," he says.

Pharmacist Bruce D. Hagmann, M.S., R.Ph., of Big Lake, Texas, has dispensed the formula for several years; he confirms such findings in patients. "It has consistently led to improved quality of life," he says.

An early improvement and a more prolonged, active and useful life can be insured with such therapy. The medicine should be considered a significant advance towards successful therapy of such chronic liver disease.

The usual therapeutic dosage is two tablets, three to four times daily. The maintenance dosage is two tablets, two to three times daily.

## GLANDULAR PRODUCTS

Glandular therapy has long been used in both traditional and mainstream medical practice. The concept behind glandular therapy is "like heals like."

### Liver Glandulars

Liver extracts are widely used in Japan. When combined with interferon treatment, liver extracts can help to

## Cautionary Remarks
## in Cases of Advanced Cirrhosis

It was reported by German researchers led by Dr. Detlef Schuppan in the October 1999 issue of *Hepatology* that use of the Liv.52 formula resulted in increased mortality among patients with highly advanced cirrhosis. In defense of the manufacturer of Liv.52, it should be noted that no scientific claims have ever been made that the formula is effective in terminal cases of cirrhosis of the liver. Furthermore, in this study, alcohol intake of the study subjects was not controlled. Ironically, the efficacy of Liv.52 may have been responsible for the increased mortality. The considerable improvement of acetaldehyde elimination by Liv.52 must be beneficial to the liver, brain, the whole organism, and well-being of alcoholics. "As a consequence, the patient advised by the physician to abstain from alcohol consumption may be less willing and motivated to do so because of feeling better with Liv.52," notes S.K. Mitra, M.D., executive director of Research and Technical Services for the Himalaya Drug Company. "On the other hand in a worse case, he may even consume more alcohol." Thus, the medicine may not be able to overcome the detrimental effect of continued alcohol consumption.

Although these findings are preliminary and represent an anomaly in the otherwise solid evidence attesting to benefits of the Liv.52/LiverCare formula, this report should, nevertheless, be taken seriously.

increase intracellular glutathione (GSH) levels and enhance nitric oxide synthase (NOS) activity, which plays a role in antiviral effects.[51]

Liver glandulars have been used for liver disease since at least 1896. Many experimental and clinical studies have shown that liver extracts promote liver cell regeneration and are highly beneficial for persons suffering chronic liver disease, including chronic active hepatitis.[52, 53] In one double-blind study among 556 patients with chronic hepatitis, persons were given either 70 mg of liver extracts or a placebo three times daily. At the end of three months of treatment, the group that received the liver extract had far lower liver enzyme levels. Since the level of liver enzymes in the blood reflects damage to the liver, it can be concluded that liver extract helped by improving the function of damaged liver cells and prevention of further damage.[54]

In the old days, people used to instinctively order up liver and onions if they needed an energy boost. "To this day, my mother will cook up a little fresh liver every now and then when she feels fatigued," says Dr. Gary Ross, a San Francisco–based physician specializing in natural and complementary medicine.

In Chinese medicine, going back thousands of years, the philosophy has been to treat a weak organ with a fresh healthy version of that organ. With that philosophy in mind, it makes absolute sense to help the liver with liver. "An acupuncturist friend of mine from China with many years of experience once told me that herbs are helpful but in tough cases the actual animal organ is more powerful as a strengthening remedy."

Fresh calf liver or liver from organically raised livestock has had less opportunity to develop any problems. It has more youthful factors and is just plain healthier. As the liver

gets older, it has filtered and detoxified a lifetime of hormones and pesticides. Whether from the butcher or in a capsule, it is crucial to use a product you trust because the liver must be free of chemicals and any disease and preferably from livestock raised on organic food.

Liver is high in vitamin $B_{12}$, iron, and liver proteins. The liver proteins contain liver tissue which consists of chains of amino acids specific to the liver.

Most consumers will probably look for a natural food supplement in some kind of capsule form. If this is the case, please try to find it in gel or liquid encapsulated form and predigested so that the body will be able to absorb it easily, thus helping the liver that much faster. Sometimes ginseng or other herbs are added to liver supplements for energy and enhanced resistance to stress. When you're feeling a little overworked, run down or when your liver clearly needs help, taking liver or an excellent liver supplement can make a difference. See Resources for recommended formulas.

### Thymus Glandular

The thymus gland is one of the glands of the endocrine system. It is found in the middle of the chest, just below the breast bone. The thymus is important in helping to fight off viruses, bacteria, cancers and fatigue syndromes. It produces the thymus hormone which the gland uses to produce thymus cells, known as T-cells.

There are three types of T-cells. T-helper cells help to regulate the functioning of the entire immune system. Natural killer cells attack invading organisms such as viruses and also cancerous cells. T-suppressor cells act as a brake on the immune system, stopping the fight once the battle has been won. These all must be in active working order or the body

runs the risk of being too weak to fight an illness or sustain the fight; in some cases, the immune system continues attacking which can then lead to auto-immune diseases such as rheumatoid arthritis and lupus.

The thymus is large and fully active during the childhood and teenage years, after which it becomes smaller and smaller. As it shrinks, it is replaced with fatty tissue and very little of the active gland is existent by the time a person reaches 40.

A number of well-done double-blind studies show that thymus extracts can be beneficial in both acute and chronic hepatitis B, reducing liver enzyme levels, helping in elimination of the virus, and causing changes in antibody status, signifying remission.[55, 56] See Resources for our recommended formula.

## VITAMIN C

Vitamin C in very high doses (40 to 100 grams), often given intravenously, has been shown to greatly diminish acute viral hepatitis in two to two four days, according to Robert Cathcart, M.D.[57] Further, he has clinically demonstrated clearing of jaundice within six days.[58] Dr. Cathcart's work is bolstered by additional practitioners' studies.[59, 60, 61]

In a well-done study, it was shown that two grams or more of vitamin C per day was able to prevent hepatitis B in hospitalized patients. Seven percent of the control patients developed hepatitis, while none of the treated patients did.[62]

## SYSTEMIC ORAL ENZYMES
## OFFER HELP FOR HEPATITIS C

A German systemic oral enzyme formula may offer profound benefits when used as adjunct therapy or possibly alone (under doctor's supervision) for hepatitis C.

In a randomized clinical pilot trial, an oral enzyme preparation (**Phlogenzym®** from Mucos Pharma GmbH, Germany) was tested in patients with chronic hepatitis C. The test drug was compared to α-interferon (α-INF), ribavirin (RVN), or liver support therapy (vitamins with trace elements).[63]

In each group 20 patients with pure, chronic hepatitis C were included and treated for 12 consecutive weeks. Efficacy was based on measurements of: (1) liver enzymes AST, ALT, and g-GT; (2) sum score of the symptoms including lack of appetite; nausea; vomiting; fatigue; pruritus (i.e., itching); spider naevi (superficial ruptured vessels); jaundice; temperature; and weight loss; and, (3) global judgement of efficacy by the physician.

Systemic oral enzyme therapy was equivalent to α-IFN, and superior to RVN and liver support therapy with vitamins and minerals. Systemic oral enzymes were rated as the best therapeutic approach compared to the other therapies. The best tolerance was documented in the enzyme group.

The researchers concluded, "The enzyme therapy seems to offer a new approach to a successful treatment of chronic hepatitis C. In this study, enzyme therapy was least equivalent to α-interferon, and superior to other treatment regimens."

Most recently, scientists at Mucos Pharma GmbH have analyzed preliminary results indicating that systemic oral enzymes combined with ribavirin produce better results than when either is used alone. These results, which will soon be published, offer further promise for hepatitis C patients.

**KEY HEALTH TIP:** Although Phlogenzym is not yet available in the United States, another Mucos Pharma systemic oral

enzyme formula that is available in this country, **Wobenzym® N**, can be substituted for the studied compound. The equivalent dosage would be five Wobenzym N tablets three times daily, then five tablets twice daily as a maintenance dose, always taken on an empty stomach, at least 30 to 45 minutes before meals or not less than 30 minutes following meals. Wobenzym N is a natural blood thinner; therefore persons with genetically inherited bleeding disorders (e.g., hemophilia) or who are taking blood thinning medication should work closely with their physician. See Resources for information on how to obtain Wobenzym N.

## LESS WELL-PROVEN NATURAL MEDICINES

These natural medicines have also demonstrated beneficial effects in cases of hepatitis but due to potential toxicity, lack of accurate identification of their chemical biomarkers or conflicting results, their use is less well-substantiated in hepatitis therapeutics.

### Catechin

Catechin is a flavonoid found in very high concentrations in *Acacia catechu* (black catechu, black cutch) and *Uncaria gambier* (pale catechu, gambier). Although administration of this natural medicine may be beneficial, Drs. Werbach and Murray warn that such administration in rare cases may cause autoimmune hemolysis. Thus this medicine should be used strictly with a doctor's close supervision. Studies have provided generally positive results, but some studies have shown no benefit.[64] This may be due to differences in raw materials utilized in studies.

## *Phyllanthus amarus*

This natural medicine has a low level of toxicity. Study results have provided conflicting evidence with some very good results and also negative findings.[65] This may be due to the type of extract used and the inability to properly standardize this natural medicine.

## *Boldo*

Boldo (*Peumus boldo*) is a South American-derived natural medicine from a tree whose leaves have long been used by native healers as a liver medicine. The scientific evidence, although preliminary, is becoming increasingly supportive of its use. It is clearly liver-protective with strong antioxidant activity.[66] It has very low toxicity.

### Putting it All Together: The Doctors' Prescription

With regard to a foundation medicine to complement doctors' therapeutic recommendations, the patient's first choice should be Liv.52/LiverCare. This formula may be used with milk thistle, licorice root and the other herbal, nutritional or glandular formulas detailed in this chapter. There are no known side effects or drug interactions with such medicines (unless otherwise detailed). For hepatitis C, Wobenzym N systemic oral enzymes should be used.

# THREE

# Designing a Natural Healing Program for Hepatitis: The Doctors' Prescription

THERE IS NO DOUBT THAT conventional medical treatment of hepatitis is essential. However, a significant amount of evidence also supports natural medicines for their ability to aid in enhancing the body's healing response. For many patients, the most wise and effective course of action will be to combine both avenues of healing, utilizing the concept of complementary or integrative medicine. Of course, working with a health care professional is essential.

There are many options available. However, with regard to a foundation medicine to complement doctors' therapeutic recommendations, there is no doubt the most clinically validated and thoroughly proven natural medicine and the one that must be used as a first choice is Liv.52/LiverCare. This formula, based on available scientific validation, is the primary formula to be recommended in all cases of hepatitis and related complications. The formula is without side-effects or drug and nutrient interactions. The evidence that supports the efficacy and safety of this formula is very solid.

As we mentioned, the Liv.52/LiverCare formula may be used with milk thistle, licorice root and the other herbal, nutritional or glandular formulas detailed in this publication.

Whenever people are dealing with chronic, debilitating conditions like hepatitis, it is essential to maintain an extremely healthy diet and to refrain from putting added demands on the liver. Therefore, we would recommend that persons prefer minimally processed, organic foods whenever possible. Such foods, grown without harmful pesticides or raised without hormones or antibiotics, help to relieve some of the detoxifying pressures on the liver and can help to improve the patient's overall health. Consuming eight glasses of pure, filtered water daily is also important.

As your hepatitis subsides, it will be important to maintain a healthy living program. Continue to use the Liv.52/LiverCare formula, possibly milk thistle. The maintenance dosage of Liv.52/LiverCare is provided on page 102. (The maintenance dosage of milk thistle is half the therapeutic dosage.)

The power to heal comes from enhancing the body's healing response. We hope that in this modest publication, we have shown you some of the most reliable methods for turning on your body's healing powers.

# Resources

**LIV.52/LIVERCARE** is available in the United States. The formula can be purchased as LiverCare at health food stores and natural product supermarkets. Known as Liv.52, it can be purchased at pharmacies and from health professionals.

To locate a health food store, natural product supermarket, pharmacy or health care practitioner, contact the company's U.S. offices.

**HIMALAYA USA**
6950 Portwest Drive
Suite 170
Houston, TX 77024
1-(800) 869-4640
Via facsimile: (713) 863-1686
Website: www.himalayausa.com

Practitioners refer all medical questions to Dr. Grace Ormstein at the above number.

**MILK THISTLE** formulas of very high quality are available from Enzymatic Therapy, Solaray, and Nature's Herbs at health food stores and natural product supermarkets and from

PhytoPharmica at pharmacies and from health professionals. If shopping in health food stores or natural product supermarkets, look for **Super Milk Thistle** with Phytosome-bound silymarin components, artichoke extract, licorice and dandelion roots. The same formula at pharmacies and available from health professionals is known as **Super Milk Thistle X**.

Additional sources of Phytosome™-bound milk thistle include Solaray (www.nutraceutical.com). Find Solaray products at health food stores and natural product supermarkets.

Another excellent source for Phytosome-bound milk thistle is LiverSupport.com. Reach them at www.liversupport.com or call 1-800-364-5722 or fax to (914) 744-5953.

**LIQUID LIVER EXTRACT WITH SIBERIAN GINSENG** from Enzymatic Therapy contains cholesterol- and fat-free liver fractions from livestock raised organically in Argentina. The fractions are predigested—broken down into peptides and polypeptides, which are smaller and more easily digested chains of bioactive amino acids. What's more each capsule contains the equivalent of 11,0000 mg of raw liver with 25 mg of a highly concentrated standardized Siberian ginseng extract. The same formula is known as **Aqueous Liver Extract** from PhytoPharmica and available at pharmacies and from health professionals.

**THYMUPLEX** from Enzymatic Therapy provides predigested, concentrated soluble extract of thymus that has been standardized for peptides and polypeptides with molecular weights of less than 10,000 daltons. It also provides other essential immune-support nutrients and herbs including zinc, vitamin C, goldenseal root and echinacea. **Thymu-Plex** is available at health food stores and natural product

supermarkets. The same formula from PhytoPharmica is called **Thymulin** and available at pharmacies and from health professionals.

**ENZYMATIC THERAPY**
825 Challenger Driver
Green Bay, WI 54311
1-(800) 783-2286
*Website:* www.enzy.com

**PHYTOPHARMICA**
825 Challenger Driver
Green Bay, WI 54311
1-(800) 376-7889
*Website:* www.phytopharmica.com

Another excellent formula for liver health is called **HEP-FORTÉ** from Marlyn Neutraceuticals. According to the 2000 *Physicians' Desk Reference*, the formula is a specially designed combination of vitamins, minerals, and glandulars that is of special value for persons whose liver has been damaged due to alcoholism, medical or street drugs and other liver poisons, and for male and female infertility due to hormonal imbalance caused by liver dysfunction. It is available in pharmacies and at drug stores nationwide. Contact:

**MARLYN NEUTRACEUTICALS/NATURALLY VITAMINS**
14851 North Scottsdale Road
Scottsdale, AZ 85254
1-(800) 899-4499
*Website:* www.naturallyvitamins.com

Excellent artichoke extract formulations are available from both Enzymatic Therapy and PhytoPharmica, as well as Lichtwer Pharma (known as **Cynara-SL™**). Visit Lichtwer Pharma on line at www.lichtwer.com.

## TRADITIONAL CHINESE MEDICINE & KAMPO FORMULAS
For more information on Japanese Kampo formulas for liver health, contact WinHerb Company at 1-888-461-5808 or online at www.honso.com or www.winherb.com.

## WOBENZYM N SYSTEMIC ORAL ENZYMES
The Wobenzym N systemic oral enzyme formula is the best natural medicine to be used as adjunct therapy in cases of hepatitis C. It is available at health food stores, natural product supermarkets, pharmacies and from health professional nationwide. It is distributed in North America by Naturally Vitamins. See the above listing for Marlyn Neutraceuticals/Naturally Vitamins for contact information.

## FOR FURTHER HELP IN LOCATING PRODUCTS . . .
For further help to find a health food store or natural product supermarket nearest you carrying any of the formulas detailed in this book, visit The Freedom Press website at www.freedompressonline.com and use the store locator service. You may also order additional Freedom Press publications online.

## FREE TRIAL SUBSCRIPTION TO
### THE DOCTORS' PRESCRIPTION FOR HEALTHY LIVING
For a free trial subscription to **The Doctors' Prescription for Healthy Living**, call, fax, mail or e-mail in your name, address and e-mail address (if available) to The Freedom Press, Inc., 1801 Chart Trail, Topanga, CA 90290. Toll-free

number: 1-800-959-9797. Facsimile: (310) 455-8962/(310) 455-3203. Website: www.freedompressonline.com. E-mail: info@freedompressonline.com.

## FOR MORE INFORMATION
**AMERICAN LIVER FOUNDATION**
1425 Pompton Avenue
Cedar Grove, NJ 07009
*Tel:* 1-800-GO LIVER (465-4837)
**(800) 465-4837 or (888) 443-7222**
*Fax:* (201) 256-3214
*Internet:* www.liverfoundation.org
  The American Liver Foundation is a national voluntary health organization dedicated to preventing, treating, and curing hepatitis and other liver and gallbladder diseases through research and education.

**HEPATITIS FOUNDATION INTERNATIONAL**
30 Sunrise Terrace
Cedar Grove, NJ 07009-1423
*Tel:* (800) 891-0707
*Fax:* (973) 857-5044
*Internet:* www.hepfi.org

**UNITED NETWORK FOR ORGAN SHARING (UNOS)**
1100 Boulders Parkway, Suite 500
P.O. Box 13770
Richmond, VA 23225-8770
*Tel:* (800) 24-DONOR or (804) 330-8500
*Internet:* www.unos.org

**NATIONAL DIGESTIVE DISEASES
INFORMATION CLEARINGHOUSE**
2 Information Way
Bethesda, MD 20892-3570
*E-mail:* nddic@info.niddk.nih.gov

The National Digestive Diseases Information Clearinghouse (NDDIC) is a service of the National Institute of Diabetes and Digestive and Kidney Diseases (NIDDK). NIDDK is part of the National Institutes of Health under the U.S. Department of Health and Human Services. Established in 1980, the clearinghouse provides information about digestive diseases to people with digestive disorders and to their families, health care professionals, and the public. NDDIC answers inquiries; develops, reviews, and distributes publications; and works closely with professional and patient organizations and Government agencies to coordinate resources about digestive diseases.

# References

1  Clayman, C.B. [ed.] *The American Medical Association Family Medical Guide.* New York: Random House, 1994.

2  Murray, M. & Pizzorno, J. *Encyclopedia of Natural Medicine.* Rocklin, CA: Prima Publishing, 1998: 512-519.

3  Luper, S. "A review of plants used in the treatment of liver disease: part two." Altern. Med. Rev., 1999; 4(3): 178-188.

4  "Liver disease meeting: an exchange of information." *Complementary & Alternative Medicine at the NIH*, 1999; VI(1): 3.

5  Hikini, H., et al. "Antihepatotoxic actions of flavonolignans from Silybum marianum fruits." *Planta Medica*, 1984; 80: 248-250.

6  Lettéron, P., et al. "Mechanism for the protective effects of silymarin against carbon tetrachloride-induced lipid peroxidation and hepatotoxicity in mice. Evidence that silymarin acts both as an inhibitor of metabolic activation and as a chain-breaking antioxidant." *Biochem Pharmacol*, 1990; 39(12): 2027-2034.

7  Valenzuela, A., et al. "Selectivity of silymarin on the increase of the glutathione content in different tissues of the rat." *Planta Medica*, 1989; 55: 420-422.

8  Magliulo, E., et al. "[Results of a double blind study on the effect of silymarin in the treatment of acute viral hepatitis, carried out at two medical centers (author's translation)]." *Med Klin*, 1978; 73(28-29): 1060-1065.

9   Fehér, J., et al. "[Liver-protective action of silymarin thera-
    py in chronic alcoholic liver diseases]." *Orv Hetil*, 1989;
    130(51): 2723-2727.

10  Ferenci, P., et al. "Randomized controlled trial of silymarin
    treatment in patients with cirrhosis of the liver." *J Hepatol*,
    1989; 9(1): 105-113.

11  Barzaghi, N., et al. "Pharmacokinetic studies on IdB 1016,
    a silybin-phosphatidylcholine complex, in health human
    subjects." *Eur. J. Drug. Metab. Pharmacokinet.*. 1990;
    15(4): 333-338.

12  Mascarella, S., et al. "Therapeutic and antilipoperoxidant
    effects of silybin-phosphatidylcholine complex, in healthy
    human subjects." *Curr. Ther. Res.*, 1993; 53(1): 98-102.

13  Vailati, A., et al. "Randomized open study of the dose-
    effect relationship of a short of IdB 1016 in patients with
    viral or alcoholic hepatitis." *Fitoterapia*, 1993; 44(3): 219-
    228.

14  Murray, M. *The Healing Power of Herbs*. Rocklin, CA: Prima
    Publishing, 1995: 243-252.

15  *PDR® for Herbal Medicines*. Montvale, NJ: Medical
    Economics Company, 1998: 1138-1140.

16  Werbach, M.R. & Murray, M.T. *Botanical Influences on
    Illness*. Tarzana, CA: Third Line Press, 1994: 176-183.

17  Sato, H., et al. "Therapeutic basis of glycyrrhizin on chron-
    ic hepatitis B." *Antiviral Res*, 1996; 30(2-3): 171-177.

18  Farese, R.V., et al. "Licorice-induced hypermineralcorti-
    coidism." *The New England Journal of Medicine*, 1991;
    325(17): 1223-1227.

19  MacKenzie, M.A., et al. "The influence of glycyrrhetinic acid
    on plasma cortisol and cortisone in healthy young volun-
    teers." *J. Clin. Endocrinol. Metab.*, 1990; 70: 1637-1643.

20  Boron, J., et al. "Metabolic studies, aldosterone secretion
    rate and plasma renin after carbenoxolone sodium as bio-
    gastrone." *British Medical Journal*, 1969; 2: 793-795.

21  Abe, H., et al. "Effects of saikosaponin-d on enhanced
    CCl4-hepatotoxicity by phenobarbitone." *J. Pharm.
    Pharmacol.*, 1985; 37(8): 555-559.

22 Tajiri, H., et al. "Effect of shosaiko-to (xiao-chai-hu-tang) on HbeAg clearance in children with chronic hepatitis B virus infection and with sustained liver disease." *American Journal of Chinese Medicine*, 1991; 19(2): 121-129.

23 Okumura, M., et al. "A multicenter randomized controlled clinical trial of Sho-saiko-to in chronic active hepatitis." *Gastroenterol. Jpn.*, 1989; 24(6): 715-719.

24 Werbach, M.R. & Murray, M.T. Op cit.

25 Gebhardt, R. "Antioxidative and protective properties of extracts from leaves of the artichoke (Cynara scolymus L.) against hydroperoxide-induced oxidative stress in cultured rat hepatocytes." *Toxicol Appl Pharmacol*, 1997; 144(2):279-86.

26 Khalkova, Z.h., Vangelova, K., Za¨ikov, K.h. "An experimental study of the effect of an *artichoke* preparation on the activity of the sympathetic-adrenal system in carbon disulfide exposure." *Probl Khig*, 1995; 20:162-71.

27 Woyke, M., Cwajda, H., W´ojcicki J., Ko´smider, K. "Platelet aggregation in workers chronically exposed to carbon disulfide and subjected to prophylactic treatment with Cynarex." *Med Pr*, 1981 32(4):261-4.

28 Angelico, M., et al. "Oral S-adenosyl-L-methione (SAMe) administration enhances bile salt conjugation with taurine in patients with liver cirrhosis." *Scand. J. Clin. Lab. Invest.*, 1994; 54: 459-464.

29 Kakimoto, H., et al. "Changes in lipid composition of erythrocyte membranes with administration of S-adenosyl-L-methionine in chronic liver disease." *Gastroenterolia Japonica*, 1992; 27: 508-513.

30 Loguercio, C., et al. "Effect of S-adenosyl-L-methionine administration on red blood cell cysteine and glutathione levels in alcoholic patients with and without liver disease." *Alcohol Alcoholism*, 1994; 29: 597-604.

31 Pascale, R.M., et al. "Chemoprevention of rat liver carcinogenesis by S-adenosyl-L-methionine: a long-term study." *Cancer Res.*, 1992; 52: 4979-4986.

32 Pandey, S., et al. "Hepatoprotective effect of Liv.52 against carbon tetrachloride-induced lipid peroxidation in the liver of rats." *Ind. J. Exp. Biol.*, 1994; 32: 674.

33 Prakash, A.O., et al. "Recovery from beryllium-induced lesions after Liv.52 treatment." Abstracted from Environmental and Occupational Health Hazards. Proceedings of the Asia-Pacific Symposium on Environmental Occupational Toxicology, Singapore, 1988; 8: 293.

34 Rathore, H.S. & Nandi, K.K. "Protective effect of Liv.52 against cadmium toxicity in mammalian systems." *Ind. Drugs*, 1992; 29(4): 149.

35 Subbarao, V.V "Liv.52 in alcohol-induced hepatotoxicity." *Probe*, 1976; XV(4): 235.

36 Ganapathi, N.G. & Jagetis, G.C. "Liv.52 in radiation-induced hepatic damage." *Curr. Sci*, 1995; 69(7): 601.

37 Yadav, S. & Yadav, R. "Protective effect of Liv.52 against anti-cancer chemotherapy in rats." Probe, 1994; XXXIII(3): 323.

38 Patel, G.T., et al. "Liv. 52 Therapy in viral hepatitis." *Probe*, 1972; XI(2): 112-119.

39 Sama, S.K., et al. *Ind. J. Med. Res*, 1976; 5: 738.

40 Singh, K.K., et al. *Ind. Med. J.*, 1977; 5: 69.

41 Habibullah, C.M., et al. "Liv-52 in acute viral hepatitis—results of a double blind study." *The Antiseptic*, 1978; 75(8): 491-493.

42 Patney, N.L. & Kumar, A. "Liv.52 in hepatitis B infections." *Probe*, 1978; XVII; 2: 132.

43 Mallik, K.K. & Pal, M.B. *Cur. Med. Pract.*, 1979; 23: 5.

44 Sinha, P.K. & Patney, N.L. "A study of therapeutic actions of Liv.52 on various stages, severity and activity of portal cirrhosis and infective hepatitis." *Probe*, 1979 XVIII(3): 157.

45 Mandal, J.N. & Roy, B.K. "Studies with Liv.52 in the treatment of infective hepatitis, chronic active hepatitis and cirrhosis of the liver." *Probe*, 1983; XXII(4): 217.

46 Mehrotra, M.P. & Tandan, S. "Liv. 52, a clinico-biochemical trial in hepatic cirrhosis." *Current Medical Practices*, 1973; 17(4): 185-188.

47 Deshpande, R.S., et al. Curr. *Med. Pract.*, 1971: 6: 810.

48 Saxena, S., et al. *Curr. Med. Pract*, 1980; 5: 194.

49 R&D Centre, The Himalaya Drug Co., Bangalore, India. (Unpublished data, 1995).

50 Chauhan, B.L., et al. *Probe*, 1988 XXVIII(1): 36.

51 Yokochi, S., et al. "Stimulation of antiviral activities of interferon by a liver extract preparation." *Arzneimittelforschung*, 1997; 47(8): 968-974.

52 Ohbayashi, A., et al. "A study of effects of liver hydrolysate on hepatic circulation." *J Therapy*, 1972; 54: 1582-1585.

53 Sanbe, K., et al. "Treatment of liver disease—with particular reference to liver hydrolysates." *Jap J Clin Exp Med*, 1973; 50: 2665-2676.

54 Fujisawa, K., et al. "Therapeutic effects of liver hydrolysate preparation on chronic hepatitis: a double blind, controlled study." *Asian Med J*, 1984; 26: 497-526.

55 Galli, M., et al. "Attempt to threat acute type B hepatitis with an orally administered thymic extract (Thymomodulin): preliminary results." *Drugs Exp. Clin. Res.*, 1985; 11: 665-669.

56 Bortolotti, F., et al. "Effect of an orally administered thymic derivative, Thymomodulin, in chronic type B hepatitis in children." *Curr. Ther. Res.*, 1988: 43: 67-72.

57 Cathcart, R.F. "The third face of vitamin C." *J Orthomol Med*, 1992; 7: 197-200.

58 Cathcart, R.F. "The method of determining proper doses of vitamin C for the treatment of disease by titrating to bowel tolerance." *J Orthomol Psychiat*, 1981; 10: 125-132.

59 Klenner, F.R. "Observations on the dose administration of ascorbic acid when employed beyond the range of a vitamin in human pathology." *J Applied Nutr*, 1971; 23: 61-88.

60 Baetgen, D. "Results of the treatment of epidemic hepatitis in children with high doses of ascorbic acid for the years 1957-1958." *Medizinische Monatchrift*, 1961; 15: 30-36.

61 Baur, H. & Staub, H. "Treatment of hepatitis with infusions of ascorbic acid: comparison with other therapies." *JAMA*, 1954; 156: 565.

62 Murata, A. "Viricidal activity of vitamin C: Vitamin C for prevention and treatment of viral diseases," in T. Hasegawa, *Proc First Intersectional Cong Int Assoc Microbiol Soc*, Vol. 3; 1975: Tokyo: Tokyo Univ. Press, 1975: 432-442.
63 Kabeil, S.M. & Stauder, G. "Oral enzyme therapy in hepatitis C patients." Institute for Tropical Medicine, Hepatology, Benha University Hospital, Cairo, Egypt; Mucos Pharma, Clinical Research, Malvenweg 2, D-82538 Geretsried, Germany
64 Werbach, M.R. & Murray, M.T. Op cit.
65 Ibid.
66 Speisky, H. & Cassels, B.K. "Boldo and boldine: an emerging case of natural drug development." *Pharmacological Research*, 1994; 29: 1-12.